Photography Demystified

Your Guide to Exploring Light and Creative Ideas!
Taking You to the Next Level!

Mozambique , Africa 2001

David McKay

As a thank you for purchasing my book, please click here to gain **UNLIMITED FREE** access to many photographic educational videos!

http://mckaylive.com/bonus

ISBN: 978-1-945177-36-1

This book is dedicated to my wife, Ally. You are so much more than an incredible photographer. You are passionate about photography, and also you are passionate about God, life, our family, nature, and the world around us.

You are the inspiration for this. Thank you for taking the journey around the world with me. Thank you for helping me to show others, through a lens, this world we live in. You have not only made me a better photographer but a better person.

I am forever thankful.

—Your David

Contents

Foreword

Even though I am primarily known as a musician and composer, my own experience with David began years ago through our mutual love of photography. I had a Myspace page back then, loaded with biographical information about me as a touring musician, playing keyboards and singing with Whitesnake, the Eagles, Don Henley, and many others. Also the page allowed for me to post lots of my photographic images and videos.

While David is a big music and musician fan, and actually plays the keyboard quite well himself, it was my photography that first prompted David to get in touch. Over the years we've also shared our mutual love for music, and he has since photographed me performing on stage in big venues and also my own inter-media performances, where I project my imagery on screens while I play my compositions.

He's been such a great support to me not only as a friend but also as an inspired colleague in the visual arts.

I was lucky enough to accompany David and his wife, Ally, on a photo tour to the Greek Islands a few years ago. It was incredibly inspiring to watch how patiently he described these techniques to his students, not dryly like a scientist but clearly as someone who is mainly interested in expressing something human, trying to tell a story, and sharing an emotion and a feeling.

For me in my own work as an artist, this was always the most important thing . . . the emotion and intent behind the content, not the process or the science.

In the beginning, when I was shooting on film, processing, and printing my work in my darkroom, I did have a very basic knowledge of the science and what to expect from using f8 as opposed to f22 and using ISO 80 as opposed to ISO 3200.

I would shoot like crazy and hope that my intention and my instincts would carry me through, magically. Sometimes, fortunately, that actually did work, but my shooting ratio was absurdly high as a result. If I got two or three usable images out of two or three rolls of thirty-six-exposure film, I'd be very pleased.

If I'd had someone like David back then, urging me to take a minute to really understand the fundamental concepts behind quality photography, especially the ability to really control your results by manually adjusting the camera, who knows how many more great images I might have captured and printed?

Fortunately, what David is doing with this series of books is allowing photographers of all levels of experience to maximize that decisive, magic moment without reducing the notion of something inspired and magical happening.

My own technique had always been very instinct-based. Until I met David, I was always very resistant to accepting technical guidance about settings, exposures, "math" of any kind, etc., because I always thought it just got in the way of my truly expressing myself.

After traveling and spending a bit of time in the field with David though, I realized that having these techniques and this knowledge at your disposal doesn't necessarily take away from the ability to organically create a memorable image but *only enhances your ability to actually make that vision, that expression, come to life.*

So here's to David, for bringing the best of both worlds together for all of us to enjoy!

All the best success to you, my friend,

Timothy Drury

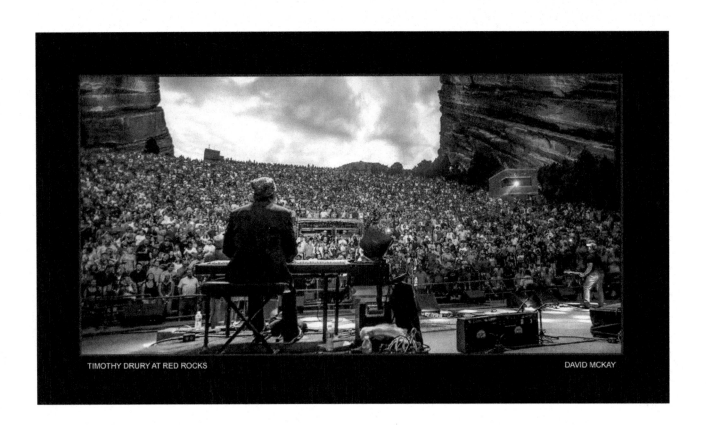

TIMOTHY DRURY AT RED ROCKS

DAVID MCKAY

Introduction

Photography Demystified—Your Guide to Exploring Light and Creative Ideas, Taking You to the Next Level builds upon the knowledge gained from my first book in the series. After reading the first volume, you are now ready to take all of that knowledge, get out there, and take even more amazing photographs than you ever dreamed. The problem—what to photograph, what specifics to consider for that situation, and when and how to do so?

Specific situations, such as times of day, specific light, gear choice, nightscapes, street scenes, people, landscapes, and more, all have certain intricacies, limitations, and issues that need to be considered when approached. Now that you have learned all about exposure, lenses, histograms, and more, in my first volume, this book is the next step in the process of *Photography Demystified*!

For those that have not yet read volume 1, I would highly recommend doing so, unless you already have a firm grasp of manual settings. It is by no means a precursor to enjoying volume 2; however, you will get the most out of this book by understanding how to use manual settings on your camera system as well as other aspects that are foundational to creating amazing photographs. These are all taught in volume 1.

In volume 2, I am going to take you to the next level with your photography. This book will give you very specific directions in making truly amazing photographs of very specific subject matter.

Photography Demystified, Your Guide to Exploring Light and Creative Ideas, Taking You to the Next Level, has been designed to get you out and shooting!

This book will give you the tools, education, and chapter "Take Action Assignments" needed to get incredible photographs of landscapes, street scenes, nightscapes, people, and more. It is filled with not only what to photograph but how to photograph each subject presented. As a bonus, an entire section is dedicated to the quality of light, the best times of day to photograph, and how to do so!

My first book in the *Photography Demystified* series became an international bestseller in two days. Given incredible reviews for its ease of use and ability to help demystify photography, it has helped thousands of people take what is a complex system and break it down into a format that is easy to use and understand. Volume 2 will do the same!

Along with my wife, Ally, I own McKay Photography Academy. I have taught over twelve thousand people, just like you, photography. I have also led hundreds of beginning photographers and photo enthusiasts on photographic tours around the world. Earning the Master of Photography and Master of Photographic Craftsmen degrees from Professional Photographers of America, the leading photography organization in the world, I have been a fulltime professional photographer for over twenty-nine years and am passionate about teaching others how to achieve great results in their photography. My heart's aim is to see that everyone can enjoy photography and to take the frustration out of the process!

Photographers, camera buffs, photo enthusiasts, and many others who struggle with understanding photography concepts, exposure, and their camera manuals have already experienced my proven methods of teaching beginning photography in volume 1. This book will take you to the next level, helping you to obtain very specific results in many types of photographic situations.

Don't be the person who has an awesome camera yet misses out on what you can do with it. Be the kind of person that others will look at and marvel at your ability to take amazing photographs. Be the kind of photographer that others ask, "How did you do that?" Most importantly, don't be the person that misses capturing the moments and memories of life that you will forever value and are truly priceless. After all, isn't that what photography truly is all about?

The photographic education, tips, and working "assignments" you are about to read are proven methods to help people create the best photographs of their lives. All you have to do to take even better pictures than you already are is to keep reading. Take control of your photographic journey right now, make it productive, and enjoy the results of capturing a lifetime of memories and moments you always dreamed of.

It is my sincere hope that you find in these pages not only knowledge but that you feel my passion and enthusiasm for photography and all it has to offer. I love photography so much and am so thankful for what it has meant to me in my life. Yet, I truly love seeing others learn and understand photography, see and understand light, and create amazing images of their own, more than anything in the world. Thank you for reading and sharing in this journey with me!

—David

How to Use This Book

Volume 2 of my *Photography Demystified* series was created to take you to another level in your photography skills. I have found that once amateur photographers have learned the basics, many times, they need help understanding and being given guidelines that will help them master more intermediate and advanced techniques.

This book is broken into three unique sections and is FILLED with helpful guidance in a variety of areas. Within each section, there are chapters dedicated to various subjects within that section. From there, each chapter is broken down into other specific areas to help you get the most out of that subject.

The first section is based on gear you will want to consider outside of your camera in order to photograph the "Take Action Assignments" given. I share with you the use of tripods, filters, and other suggested gear for specific photographic situations.

Section 2 is all about exploring light. You will learn all about the various types of light and how to photograph in them. Lighting techniques for sunrise, sunset, nighttime, and twilight hours are all explored and taught. Within each of those chapters, we will explore very specific situations, such as cityscapes, the golden hour, and the blue hour.

Section 3, "Creative Ideas," is filled with a variety of subject matter that can be applied to various types of light you will have explored in section 2. You will learn how to control and create movement of water, panning techniques, silhouettes, the basics of street photography, and MUCH more!

Beyond this, as in my first book, you will have very specific "Take Action Assignments" along the way. These are meant to get you out and actually shooting. If you do these assignments and follow the techniques and procedures laid out, by the end of this book you will have obtained an immense amount of knowledge on the subject matter presented. Once again, this will demystify much of the frustrations and techniques needed to create amazing photographs!

Here is just a sample of the assignments you will be engaging with:

- Sunrise and Sunset

- The Blue and Golden Hours

- Controlling Water Movement

- Learning to Pan with Movement

- Street Photography Basics

- Reflections

- Flashlight Photography

- How to Photograph Fireworks

- HDR Techniques

- And MUCH MORE!

About the Photographs Included

I have taken the approach of including even more photographs in this edition in order to give actual visual examples of the subject matter discussed. After all, we are discussing photography, so it should stand to reason that photographic examples are included! The photographic examples I'm sharing are photographs I took as well as some that Ally took, as indicated. It is important to note that for every bit of subject I write about, I personally photograph the same subject matter and adhere to the very teaching I share with you.

It is very important to me not only as a writer, but first and foremost as a photographer and educator, to inspire you to take the knowledge presented and to get out and try it yourself.

I believe that by showing you many photographic examples, it will spark ideas and thoughts for you to use when you are taking photos. I have also included in many of the photographs presented, the settings at which the images were created. This will help you, as you are learning, to have a reference on how to create this type of photograph you are working to achieve.

My hope is that you enjoy my images and more than this, that they inspire you to create for yourself photographs that you will treasure and be proud of sharing with others.

ISO 800 I/800TH F7.1

Section One

Preparation and Gear

One of the common mistakes new photographers make is not having their gear prepared prior to arriving at a location to shoot. I have watched time and time again as beginning and sometimes, not so beginning photographers are spending precious time fumbling around with gear that could have been ready the night before.

As I previously talked about in volume 1, preparation and foundation are keys to success. Otherwise, you will be working at a disadvantage, trying to get prepared while you should be shooting. This leads to frustration and mistakes. Below are some helpful hints to have ready prior to leaving for a shoot.

General Shoot Preparation for All Times

- Memory cards should be formatted and ready for use.

- Camera settings should be set to RAW and JPEG.

- Gear should be clean and ready to go the moment you arrive at a shoot.

- Batteries should be fully charged.

- Lenses should be clean and free of dust.

- Tripod legs and feet should be checked that they are not loose, and an extra tripod attachment plate should be packed.

Tripods

One of the biggest situations my wife, Ally, our team, and I have to deal with every photographic tour is the use of tripods. It seems that no matter how much we explain ahead of time that a good tripod is a necessity for certain shoots we will be doing, people either ignore our advice or simply think they can get by with a cheap drugstore or electronic store brand.

Your images, in certain lighting conditions we will be discussing, are only as good as your camera can be stable! Do NOT have an expensive camera and place it on a flimsy tripod! It will do you no good, and you will not get the results I am working to help you obtain.

There are many well-made, decently priced tripods available. There is not a need for you to have the most expensive tripod. However, a thirty-nine dollar off-brand tripod from the local Target or Best Buy will NOT suffice. Any movement from wind, vibration, or just the fact that the tripod cannot hold the weight of the camera will ruin your images. You have been warned!

The other issue with tripods is this—do not wait until you are out on a location to learn how to set it up. Nothing can be more frustrating than a beautiful morning sunrise happening and watching people fumble around, trying to work their tripods.

Prior to going out on a shoot, learn your tripod—how it works and how to set it up easily.

Tripod Tips

- Know how to operate your tripod ahead of time.

- While shooting, always make sure everything is tightened and secure.

- Carry an extra plate attachment in case one gets lost.

- Do not twist the camera while on your tripod. Only use the tripod controls, or otherwise your camera will become loose.

- As much as possible, keep one leg pointed forward towards your subject for security purposes.

- Lower the legs of your tripod from the top down, utilizing the largest legs first.

- Only use the center pole for height if absolutely needed. It is the least stable portion of a tripod and also allows the wind to move your camera more.

- If your tripod legs are the twist-to-open type, <u>only twist one-fourth of a turn to loosen</u>. Tripod legs are a pain to try and get back in if they slide out. There is no need for more than small turns when loosening and tightening tripod legs.

Cable Release

When working with long exposures on a tripod, it is very important to not have any camera shake occur. Even the slightest touch of your camera by depressing the shutter button by hand can cause your image to be ruined.

In order to avoid this, a cable release is highly recommended. Inexpensive ones that plug into the camera are very affordable. For a little more expense, you can also purchase remote releases that allow you to be completely hands-free while shooting long exposures.

Be sure that your cable release has the ability to "lock open" your shutter. As we get into the assignments in this book, you will find there are times when you may want to have your shutter open for extended periods of time long past even thirty seconds. The lock-open release will allow this to happen.

Filters

Filters are an excellent tool to have ready in your bag. With that said, understand that although filters can and do help in various situations, I recommend that they are not used all the time and only when necessary.

I view filters like this. I do not use them very often, but for the certain times when I need one, it is a tool in my bag that will allow me to accomplish my goals for an image I may not otherwise be able to. For that reason, I carry filters with me. Although not used often, when I need them, they are a great asset in my camera bag.

Have you ever purchased a really nice pair of sunglasses? You know—an expensive pair of Oakleys or Ray-Bans, for example? If you have, you understand that the moment you put them on, you will have a hard time going back to the cheap, inexpensive ten-dollar pairs from the local drugstore.

Why? Because of quality! Filters are exactly the same. Just like our eyes that are in fact lenses, filters are like a pair of glasses that go over top. The better the quality, the better you see.

The main reason it is my suggestion to not use filters unless needed is due to the possible loss of quality in the images, namely, sharpness, when using a filter. The question I always ask myself if I am going to use a filter is this—can I obtain the image I want without the use of a filter? If the answer is yes, I will avoid using the filter.

For example, maybe I really want to bring out the rich quality of the blues in the sky, and a polarizing filter can help with this. If I can do that in post-production, I will prefer to do so there versus the use of a filter.

Here is why. If you have a very expensive lens, for example, the glass in that lens is what you primarily paid for. Let's say you have a one thousand-dollar lens. Now, let's say you have a twenty-dollar UV filter on that lens to protect the glass. It is true that you may be protecting your expensive lens, but the reality is you are now placing an inexpensive, not nearly as high of quality piece of glass in front of the beautiful glass in your lens.

The whole point of having a nice lens is to get amazing images that are sharp and excellent. I personally see no reason to place an inexpensive piece of glass over that lens that will in fact decrease the quality of your glass substantially. Yes, this means you need to be more careful with your expensive glass. But shouldn't you be anyway?

Another way to help protect that lens is the use of a lens shade. I will keep my lens shade on as much as possible and only take it off once in a while, for very specific situations. A lens shade does far more than just keep the sun from giving flare when shooting. It protects your lens. By having your lens shade on, regardless of the light, you will create a distance between the glass and whatever you may hit it against.

Let's take a look at the many various types of filters there are and when you may want to consider using one. This is by no means an exhaustive list; however, it will give you an excellent understanding of many of the most common filters used.

Filter Systems

There are two basic types of filter options people use: the screw mount and the slide-in system.

The screw mount filter simply screws into the front of your lens. The advantage of this is that it is very secure and will not easily come off. The disadvantage is that if your lens diameter openings vary from lens to lens, you need a filter the size of each opening. This can be expensive.

However, if it is a small degree of size difference, there is what is known as step-down rings that attach to your lens and then allow you to screw the filter onto your other-sized lens. As an example, you can take an 82-mm filter and place it on your 77-mm opening lens by applying a step-down ring to the lens itself.

One other note of caution is to not screw your filter on too tightly. If you do, it can be a real pain to try and get off, and you can strip the threads on your lens.

With the slide-in mount system, you purchase a filter holder that fits onto your lens. Then you purchase filters that simply slide into place over the lens. Cokin and Lee are the most notable companies that manufacture these systems, with Lee being the more expensive, but the higher-quality option.

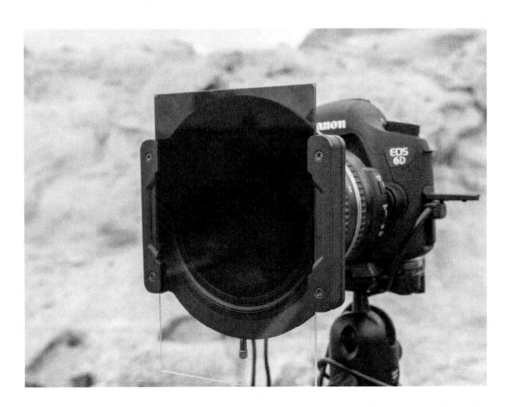

The disadvantage of this system is that it is easier to knock the filters off your lens. Although secured via the system itself, a heavy knock to that system and your filters can go flying.

This is one of those items in photography that is truly subjective as to what you may prefer. I personally use both but tend to use the slide-in system the majority of the time if I am using filters.

I tend to prefer the slide-in system because I can easily use the same filter on a variety of lenses. Plus it is very easy to "double up" on the filters if I so choose.

Glass vs. Plastic

Filters come in both glass and plastic. Without a doubt, glass filters are much better although they do cost more. Understand that filters, just like lenses, come in a variety of quality and cost ranges. The most expensive can be three or four hundred dollars per filter!

For the majority of amateur photographers, there are decent filters made by companies, such as Hoya and Tiffen, that are excellent for the value. However, if you find yourself on the more serious side of photography, consider spending a bit more on the best quality.

I do not use very many filters, but the ones I do have are very high-quality because if I am going to place something over my expensive lens glass, I want it to be excellent quality.

UV Filter

This is the classic, clear filter, that every camera store will try and sell you to protect your lens. Yes, it will help protect your lens, but at what cost—the cost of a sharp image?

Again, I look at it this way. If I have a $1,500 lens and I am placing a $50 filter over it, there is a reason the filter is only $50. You are taking your high-quality glass and placing a piece of glass that is not near the quality over top.

Yes, it will help protect your glass, but again, isn't the point of high-quality lenses to get the best images possible?

These filters do absolutely nothing for your photography, and personally I do not use one unless I am working in situations where I am banging around my gear a lot. Even then, I find that by having my lens shade on, I will do more to protect my lens than a filter.

If you prefer to keep a UV filter on for added protection, by all means do. I just want you to understand the pros and cons of some of these items.

Polarizer

A reason to use a polarizer is just like you would with sunglasses—it helps to bring deeper saturation in color, to cut down glare, and to take away haze.

You will notice that the blues and greens are more vivid, for example. I find the polarizing filter extremely useful in diminishing glare off of water.

Circular polarizers allow you to rotate the filter in order to define which area of your image you want it to have the most effect on. I highly recommend a circular polarizer for your filter selection.

As you can see in the two images below, the difference in the sky is substantial with using a polarizing filter.

My choice on whether to use the filter still comes down to whether I can do what I want more easily in post-processing, such as Lightroom or Photoshop. If I can, I will use the software versus placing filters over my expensive lenses. However, if the filter really helps and makes my images better and I need the filters for something, such as glare, I have them in my bag, ready to go.

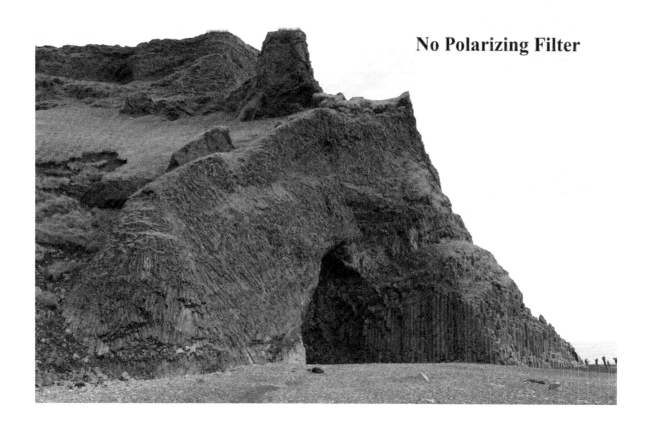

No Polarizing Filter

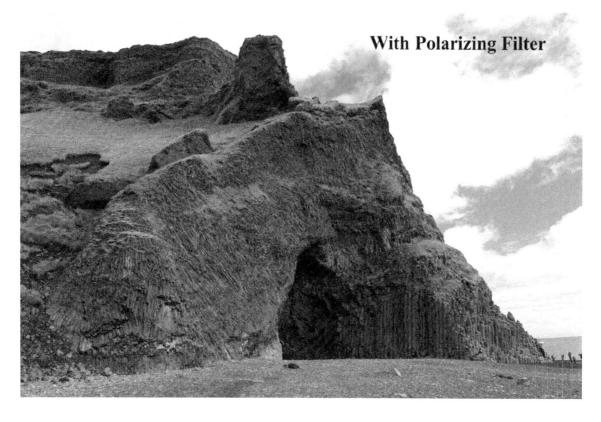

With Polarizing Filter

ND Filter

ND stands for "neutral density." These filters come in a series of coatings in order to take away light. Filters are numbered from one to ten with the number signifying the amount of stops of light being taken away. For example, a #5 ND filter reduces the amount of light coming in through the lens by five stops.

These filters are excellent for reducing the amount of light in the middle of the day in order to be able to do long exposures of waterfalls, rivers, and more (see "Water and Motion" chapter).

It is possible to purchase a variable ND filter. This is a single filter that is from #1 to #10 on the scale of degrees of light taken away. However, I find that if you use a large f-stop, such as f22, due to the depth of field being captured, you can actually see the variance between the ranges in your image. This is not a good thing!

For this reason, I recommend purchasing a specifically numbered filter for your taste. I personally recommend a #8 if you are new to this and need to buy just one to start out with.

I will go over in detail how to use this filter in the "Water and Movement" chapter.

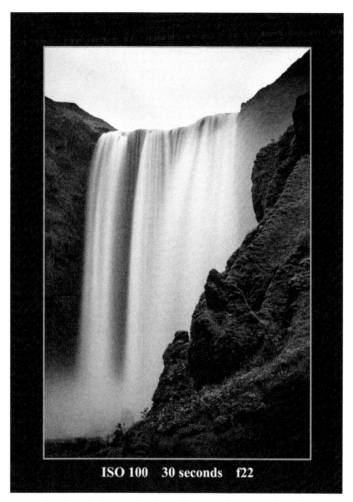

ISO 100 30 seconds f22

In the photo above, I used a #10 ND filter during the middle of the day to allow for a thirty-second exposure.

Graduated or Split ND Filter

A graduated ND filter will allow you the ability to work in situations where the light is split. In other words, maybe the top half of your subject is very bright, and the bottom half is in the shade.

This filter allows you to even out the exposure because part of the filter is dark and the other part is light. This is particularly useful when photographing scenes in locations, such as Yosemite, where the mountain range may be lit by direct sun, but the valley floor is in the shade.

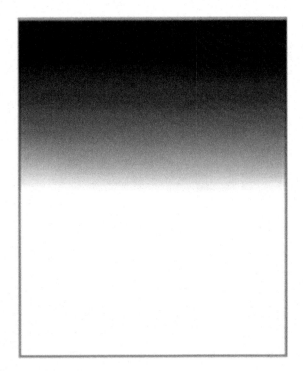

Metering Systems

In volume 1 of the *Photography Demystified* series, I spent a great amount of time explaining and teaching the exposure triangle and how all of the manual settings work in order to get the most out of your photography. Hopefully, if you are reading this, you have a basic understanding of the exposure triangle and using manual settings.

If you do not and have not yet read *Photography Demystified, Volume 1*, I HIGHLY recommend reading that first. It will help you with the rest of this book and give you an excellent foundation for your photographic endeavors.

In my first book, I discuss in depth the light meter. You should have a grasp on using your light meter now and aligning the needle center to get your exposure.

As we proceed into very specific lighting situations, I want you to be aware of the various ways a camera works to read light and evaluate exposure.

There are three primary settings you can set up most cameras to evaluate light.

They are:

- overall

- partial or center-weighted

- spot

When you look at a scene through the viewfinder, how your metering system is set will decide how your evaluation of that scene's light takes place. As you adjust your settings to get the correct exposure, the meter moves, but it is based on the setup you have chosen.

Overall

In this setting, the meter is set to take into consideration the entire scene and all of the light. This is typically how your camera comes out of the box. As you work to obtain exposure, the light meter you are using is basing the information on everything in the entire scene and then averaging it out.

This will work fine when lighting is even across a scene. However, so many times that is not the case. If you have a lot of highlights and shadows in the same scene, you may struggle to get the exposure you desire.

Partial/Center-Weighted

This metering setup uses just a portion of the area in the scene. It is set to use the center portion of your viewfinder to obtain the readings. I tend to use this metering system the majority of the time.

The reason I like it is that I will aim my camera at a specific area in my scene, obtain my exposure, and then recompose my image how I like best. I prefer to take into consideration more than just the specific, main subject but also some of the areas just around it in order to not over- or underexpose those too much.

Spot

The spot meter allows you to pick a very specific portion of your scene and obtain your exposure on that area only. By simply pointing the center of your lens directly at the specific area, the metering system is evaluating only off of that spot.

This is particularly useful in situations where you want to make sure that a very specific portion of your scene is the perfect exposure.

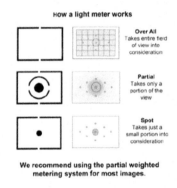

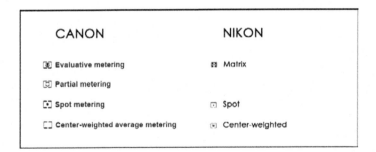

Take Action Assignment

- Locate your metering system in your camera. All systems are different, so you may have to use your camera manual.

- Go outside and take three photographs of the same subject but in a lighting situation that has both highlights and shadows.

- Pick one specific subject within your scene to use as your metering guide. An individual adult or teen would be a great test subject for this. Use the three various meter systems, and align your light meter with the needle center.

- Take notice of how each image has a slightly different exposure.

Note: Regardless of what meter system I use, I ALWAYS check my histogram to make sure my exposure is good. (See "Histogram" in volume 1.)

Section Two

Exploring Light

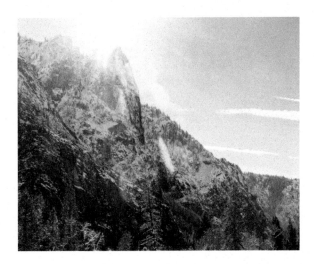

Photography is all about light. It has always been about light. In fact, the very meaning of the word "photography" means "to draw with light"! I like to use the term "painting" with light. We, as photographers, are in essence harnessing light, using it to reflect off of a subject and record to our sensor or film. We are in the very real sense of the word, painting with light. Without light, we do not have photography.

As light is truly the essence of photography, it is important we take time to explore light. Before I get into specific subjects and the how-to of those subjects, I want to set the correct foundation. As in my first book, you know that the foundation is the key to a great image. I am not one that cares for the attitude and mindset in photography that is of "let's shoot it and fix it later."

We are going to start with various types of light and how you need to pay attention and PLAN for the images you want to attain by always considering light. As you continue on your photographic journey, NOTHING becomes more important than the light you are photographing in. Neither your fancy equipment nor your post-production skills in Lightroom or Photoshop will do for you what the best light does when it comes to photography. Sure, those items might help, but realize, it is NOT the camera that makes a great photograph; it is the person behind it. Without the best light, your photography will not be what it can be.

I have to admit this is one of the great loves of mine with photography. No matter how great of a photographer I might be, or become, I MUST rely on creation to give me the results to capture. Some days, it is as if nothing seems to come together.

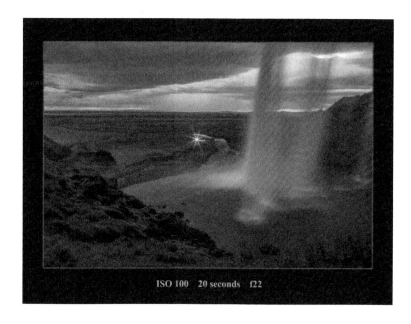

ISO 100 20 seconds f22

Much like a fisherman going out in the predawn hours to catch the big one yet becoming disappointed when it doesn't happen, photographers must do the same thing. As photographers, we are always hoping and praying for the right light, but we are willing to just enjoy the fact that we are shooting even if it's not there. Yet, there are those days, those magical, incredible, memorable moments, that happen when everything seems to be just right. It is those moments that allow us, photographers, to come alive and capture incredible beauty while much of the world is still asleep. This is one of my great passions in photography and one I never grow tired of.

Just because we cannot guarantee what the light will be on any given day does not mean we cannot do our best to predict a basic outcome. With today's technology, we are afforded a multitude of ways to gain information and predict what light may happen and when. Apps, such as TPE (The Photographers Ephemeris), are extremely helpful in showing not only when the sun is coming up or setting but the angles at which it will rise and even hindrances that may be in a shot, such as a building or obstacle, based on the GPS data we can load!

The app does the same for the moon. Simply type in a location, and the app will show for the day you are considering exactly where the moon will rise, set, and any obstacles that may be in the way. That is pretty incredible!

The one item an app like this or all the technology available today cannot do—predict with perfect accuracy the weather! I do not care how good your local weather person is, weather will be what it will be, and more often than not, I would have missed incredible images if I had not gone out shooting because I listened to the weather predictions. Just like fishing—you never know! In fact, some of my most incredible images have come during a five-minute break in a storm. Why? Because the light can be magnificent when storm clouds break!

So let's talk about light and times of day.

Predawn—Twilight/Blue Hour

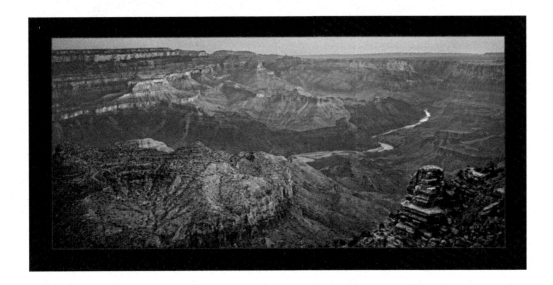

You may have heard the saying that the early bird gets the worm. I like to say that the early bird gets the awesome photograph! Now some of you are already shaking your head because of your disdain of waking early, especially before the sun is up. Believe me, I KNOW. I am NOT a morning person, and when an alarm goes off at some ridiculous time of morning when it is still dark out, no one more than me wants to roll over and go back to bed.

So why do I get up? Why do I drag myself out of that nice, comfortable, warm bed? Because I know that if I don't, I may miss one of the most incredible moments I can have as a photographer. You would be correct to assume that many times I have gotten up and gone out shooting only to get average results or light.

Here's a secret though: once I am up, coffee in hand, and headed out the door, an excitement takes place over me. My adrenaline goes, and the day feels alive! The crisp, fresh morning air, the stillness of predawn on the streets of an Irish alleyway, the quietness of being alone in Yosemite National Park, the brisk chill in the air wherever I may be, lets me know I am alive. Suddenly, getting up wasn't so bad after all, and whether I get a great image or not, I feel alive. That is worth it for me.

Yet, those mornings when the predawn light is magical, oh those mornings, they are more than just feeling alive. They are moments I not only capture with my camera; they are moments I capture with my heart. This is what photography has done for me and can do for you.

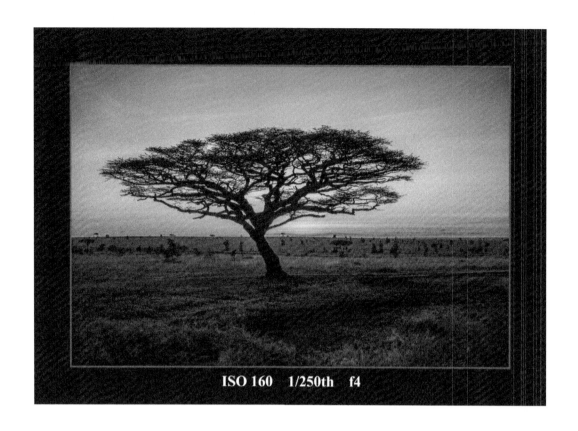

ISO 160 1/250th f4

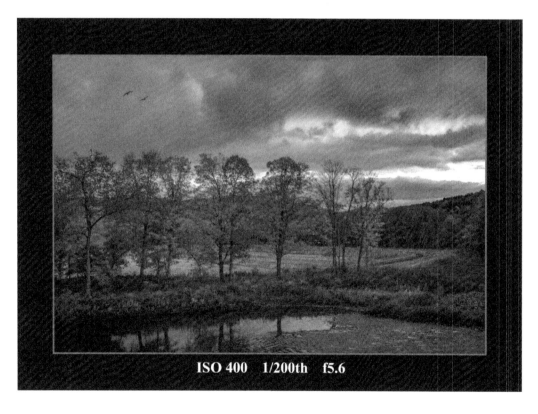

ISO 400 1/200th f5.6

The predawn twilight hour can have some of the most dramatic skies in all photography. As the sun is rising and the light is reflecting in the clouds, the color that can be achieved can be breathtaking.

Here is an example of one of those moments. My wife, Ally, and I lead photographic tours all over the world, and Yosemite is one of our favorite locations. I have photographed Yosemite several times. Of course, with so many amazing photographers, most notably Ansel Adams, being an inspiration, Yosemite is an awesome location to shoot.

In Yosemite, Tunnel View is one of the most iconic locations ever photographed. In fact, I have heard that it is one of the top three popular locations in the entire world for photography. The view faces east. This presents a bit of an issue when the sun is coming up over the mountains as the light will hit you directly in the lens. Arriving at predawn can afford you magnificent images depending on the cloud cover. If it is completely clear, there will be no color in the sky from the sunlight reflecting on the clouds. On the other hand, many times the cloud cover can be so thick that you do not see anything.

For years I have waited for the right opportunity for an image of predawn color at Tunnel View. One morning on a recent fall color tour we were leading in Yosemite, one of my instructors Jack Thatcher (a self-proclaimed techy nerd) came to me and said that it was about a fifty-fifty chance the following morning would have some color based on all his data (his app). I thought for a moment about how much I needed sleep as we were out late shooting that night, and then I thought about the advice I just shared with you above.

We had to get up at 4:30 that morning to make it to Tunnel View for the right time. It was truly one of the best times I have ever had there. Plus, there were no crowded tour buses full of tourists everywhere. We had the most incredible, God-created views in the entire world, for a moment, all to ourselves.

This is a result of that effort.

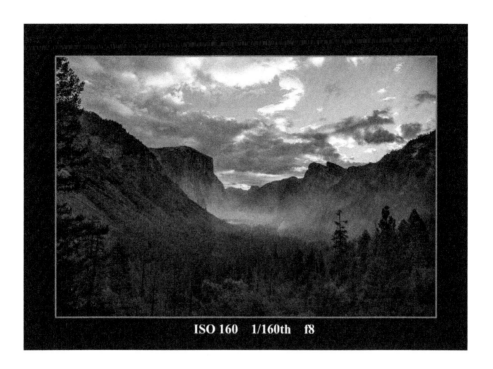

ISO 160 1/160th f8

Take Action Assignment: Twilight Morning

Preparation and Technique

- Scout out a location, and find out what time sunrise is for the morning of your shoot.

- Prepare all of your gear the night before, and be ready to shoot the moment you arrive.

- Arrive NO LATER than one hour prior to sunrise (coffee in hand).

- Make sure you have a tripod and a cable release. (If you do not own a cable release, use your self-timer to avoid camera shake.)

- Set your ISO to 100.

- Choose your aperture based on the depth of field you desire (f8 is usually fine for most situations).

- Align your shutter speed to the center of your light meter for the proper exposure. (Remember, it will be a long exposure at this time of day due to low light. As long as you have a steady tripod, you will be fine.)

- After you take the image, check your histogram and make sure you are not overexposing and blowing out any highlights in the clouds (see "Histogram" in volume 1).

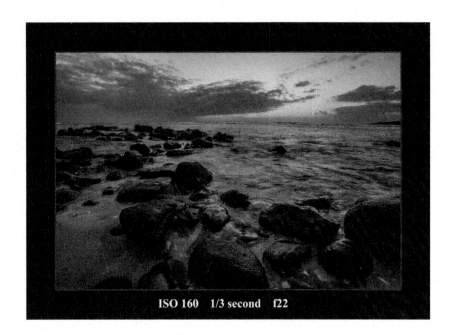

ISO 160 1/3 second f22

Evening—Twilight/Blue Hour

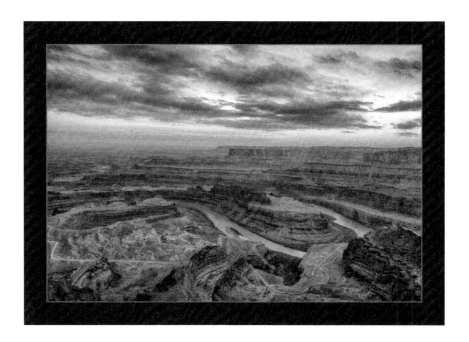

Just as there is a twilight time period in the mornings, there is also a twilight period in the evenings. Believe it or not, there is actually a quality difference of light. The mornings tend to be a bit softer, and as the sun rises, the reflections of the light against the sky tend to cast a soft quality to the light that is very pure in the morning time.

In the evening, I tend to notice that the depth of the color saturation in the blues is much deeper and stronger, and has a bit more harshness to it. Not to say that it cannot still be soft at times, but typically, there seems to be stronger, deeper tones in the evening twilight times.

My other discovery is that during the evening twilight, although many call it a blue hour, it is anything but an hour. In fact, usually there is about thirty to forty minutes, tops, on the quality of twilight color I am looking to produce in my photographs.

Cityscapes

The evening at twilight is my favorite time to photograph cityscapes. In fact, as I lead people on photographic tours, I specifically plan on creating images with them around this time as much as possible when we are in city locations. For instance, Prague by the river (image below) at twilight is much more dramatic than Prague by the river, midday.

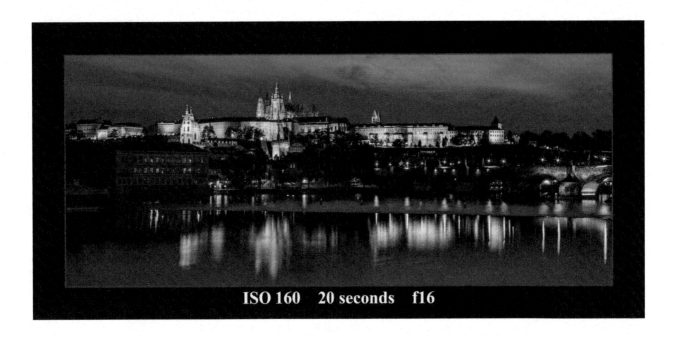

ISO 160 20 seconds f16

It is much more dramatic to have the beautiful scene of lit architecture against a deep blue sky rather than a solid black sky, in my opinion. When photographing for this specific purpose, there are several items to think through.

The number one item of course, is to be aware of exactly when the right time will occur. The time to be READY to start your shoot is usually about twenty-five to thirty minutes just past the actual sunset. You need to be ready and prepared to shoot the moment the sky starts giving the deep blue hue you are looking for. Remember, you do not have much time.

It is also important that after you shoot in one location, you "move your feet" and quickly shoot as much as you can of the scene from as many different perspectives as possible in that short amount of time. If you are busy getting your gear ready, you will be limiting your options for various perspectives of the scene.

I recommend arriving at your location thirty minutes ahead of sunset and planning out your shoot. This will give you time to make sure your camera gear is ready, and you are able to put some forethought into the locations you want to photograph, as well as the various compositional possibilities for your images.

Once you have set up for your first images, it is a waiting game. As the sun sets, you will start to notice the transition in the color of the sky. If you take images at this time and the sunset is happening behind you, the sky will simply be a light color and not very dramatic. Be patient.

As I mentioned, about twenty-five to thirty minutes past the actual sunset, the blue hue in the sky will start to show. Now you will go from being patient and waiting, to shooting as much as you can,

in as many possible locations for that scene as you can, all in about thirty minutes of time. It is a rush, and the resulting photographs can be extremely rewarding!

ISO 100 30 seconds f9

For this type of shoot, a low ISO is still the best option as you will be accumulating light in your exposure over time. Once again, a steady, well-built tripod is the key. Start by choosing your aperture based on the depth of field that you want.

Once again, f8 is usually just fine for most scenes unless there is a lot of depth and your relationship to the subject is close. If it is a scene that is a ways out, the f8 is an excellent place to start. Depth is relative to how close you are to a subject, and there is no need to shoot at a large numbered f-stop if the scene does not warrant it.

I would prefer to use the sweet spot of my lens as much as possible, and f8 for most lenses falls into that category.

Now, simply align your shutter speed using the light meter. You may find that your image tends to be overexposed a bit in these situations when the light meter is perfectly centered. Check your histogram, and by all means if you need to, underexpose to get the results you need. You will also find that by slightly underexposing, you will get more saturation in your color. The blues will tend to be "bluer," for example.

Take Action Assignment: Evening Twilight—Cityscape

Preparation and Technique

- Scout out a location and find out what time sunset is for the evening of your shoot. Predetermine various vantage points to photograph from. Consider various compositional possibilities as well.

- Prepare all of your gear and arrive at the desired location a minimum of thirty minutes prior to sunset.

- Make sure you have a tripod and a cable release. (If you do not own a cable release, use your self-timer to avoid camera shake.)

- If you are photographing and there is wind, be sure to keep your tripod weighted down. I recommend that you try to keep exposure times shorter in order to avoid "shake" that may occur from the camera being moved by the wind. This may mean you need a higher ISO in order to keep the shutter speed faster.

- Set your ISO to 100 to start.

- Choose your aperture based on the depth of field you desire (f8 is usually fine for most situations).

- Align your shutter speed to the center of your light meter for the proper exposure. (Remember, it will be a long exposure at this time of day due to low light. As long as you have a steady tripod, you will be fine.)

- After you take the image, check your histogram and make sure you are not overexposing and blowing out any highlights. If windows or lights on the buildings are blown out, that is to be expected. Do not worry about this (see "Histogram" in volume 1).

- Underexpose your image and check the results. You may find you prefer a slightly underexposed image in this type of photograph as the color saturation can be much deeper.

- As the evening progresses and it gets darker, simply adjust your shutter speed to stay open longer to keep the proper exposures happening.

- Once you get to thirty seconds on your shutter speed, the next option is to use the "bulb" setting, and time the length of your exposure.

- Another option is to open up your f-stop (smaller number), and then when you are out of room there, if you do not want to go past thirty seconds, simply raise your ISO sensitivity.

Sunrise and Sunset—The Golden Hour

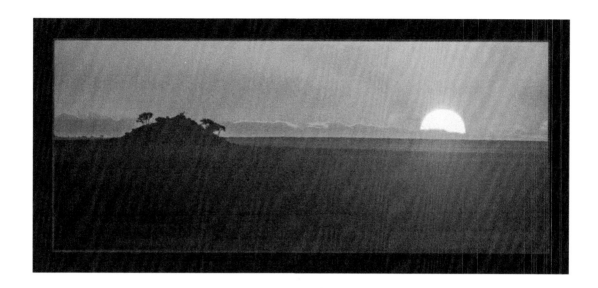

Many people refer to the "golden hour" or "magic hour" as their favorite time to photograph, especially due to the beautiful, soft quality and warm tonality of the light. This is the hour (sometimes minutes) just after sunrise or just before sunset. This time of day affords the photographer the possibility to shoot with a much softer quality of light (as opposed to harsh), and the shadows and tonality tend to also be much softer.

As with photographing at predawn, you need to be ready to shoot the moment the opportunity presents itself. The type of light that happens during this timeframe is actually very rarely a full hour. Typically, it is usually minutes during which you will get your very best light.

As the sun either rises or sets, and is at an angle rather than overhead, you will be able to attain the beautiful, warm tonality not available at other times of the day.

Although there is nothing wrong with photographing a beautiful sunrise or sunset, it is important to understand and pay attention to WHAT the golden hour light is doing. Many times I have watched as people get fixated on the sun itself, rather than what the light itself is producing all around them.

This image below in Greece is one of my favorite sunset images. During this time, many people were fixated on the sunset itself. Yes, it was beautiful; however, it was what the quality of light was doing to this church that caught my eye.

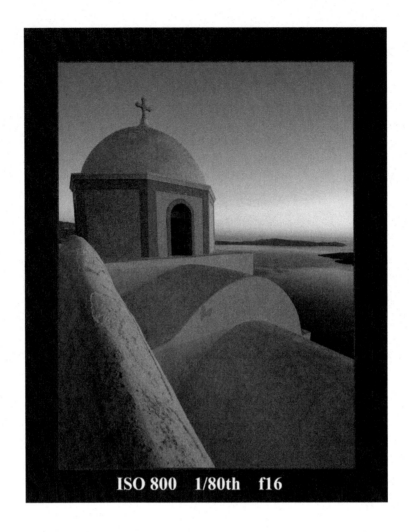

ISO 800 1/80th f16

I am always looking at what the light is doing, not just the source of the light!

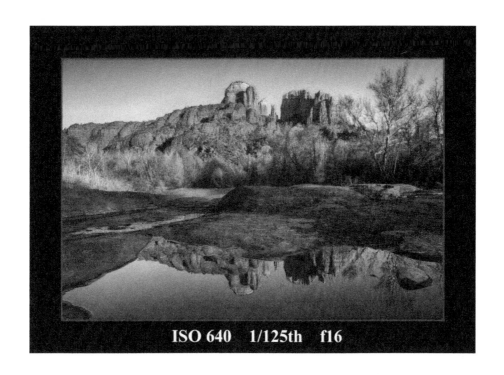

ISO 640 1/125th f16

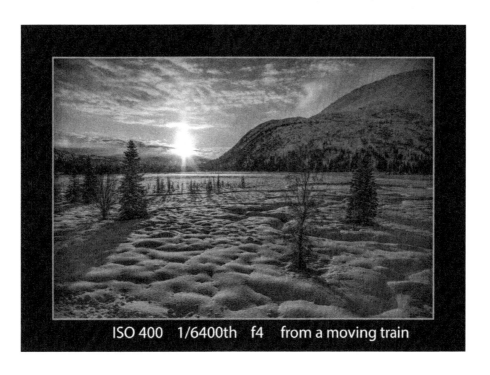

ISO 400 1/6400th f4 from a moving train

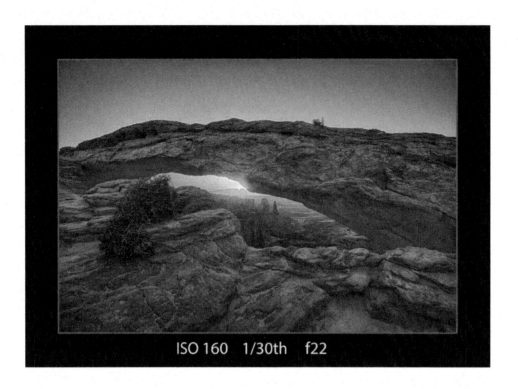

ISO 160 1/30th f22

Take Action Assignment: The Golden Hour—Landscape

Procedure and Technique

- Follow the same procedures as in the morning and evening twilight photography "Take Action Assignments," but create a golden hour landscape.

- Be diligent in making sure the quality of light is the beautiful, warm tonality, such as in the images above.

- Try various white balance settings. You may find that the cloudy preset gives you the best results.

The golden hour light is an excellent time to photograph posed portraits, people, and wildlife, as well as landscapes. You will notice that the tonality of your color in your landscapes will be beautiful and probably expected. However, this is a great time to photograph people as well. Skin tones can be extremely beautiful and warm.

As the sun rises or sets, the angle of the light is not overhead. Midday light tends to be much harsher and also creates deep shadows in the eyes as it is above your subject directly.

During the early morning or later afternoon timeframe, just after sunrise or prior to the sun setting, the light is much more even in quality. Therefore, it is much better for portraits. It is also directional, meaning it is at an angle versus directly overhead. This gives us various options we can work with.

By using this light, your portraits can have excellent results and added dramatic lighting to help ensure impact! In learning to photograph portraits that are actually posed situations, I would recommend using individuals, versus groups, as you learn.

Be diligent in making sure the quality of light is a beautiful, warm tonality. Start your portrait session two hours ahead of sunset. By doing this, you will be able to get yourself, as well as your subject, relaxed. This way, by the time the best golden hour light arrives, you will already be in the "flow" of the session.

In this portrait session of musician Stephan Hogan, these images were all taken during the same shoot at the same time of day. However, notice the dramatic differences that resulted in my using the various angles of light.

In the first image, I used the warm glow of the afternoon sun as a dramatic sidelight. This is not something I would do for a "soft light" portrait. However, for this session, the results work great. Notice the beautiful glow in the background as well.

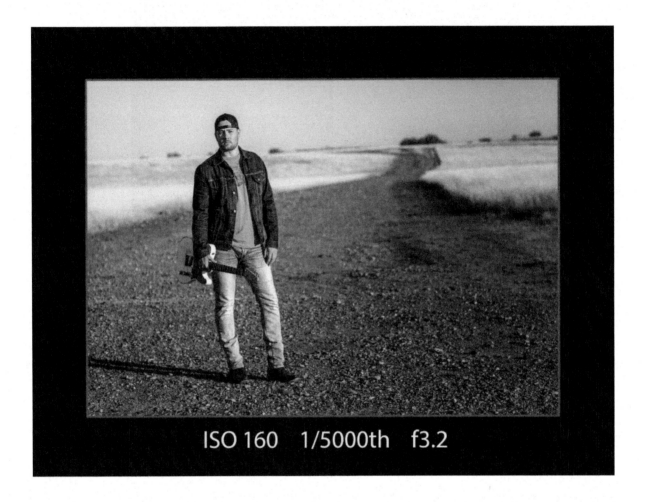

ISO 160 1/5000th f3.2

In the next image, I purposely used the sun and backlit my subject, meaning the light comes from behind. This can be tricky, and you have to work with exposure a lot to get the correct results.

Also, I used the sun and allowed for the "flare" to create some dramatic effect.

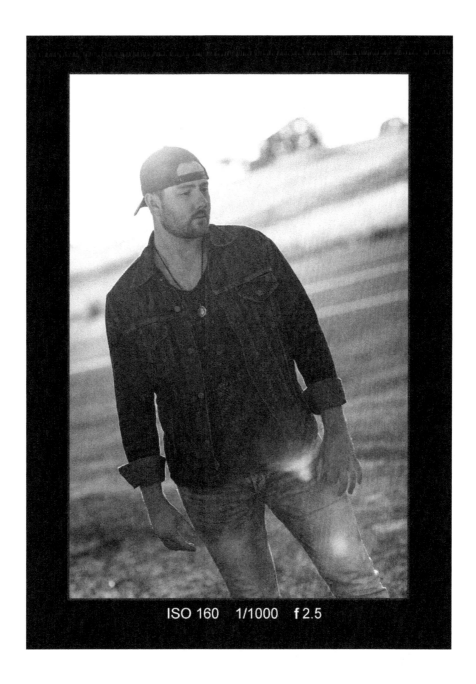

ISO 160 1/1000 f 2.5

In the last image shown below, simply by changing my angle to the sun as to not get flare and then using a bit of flash or a reflector, I could get some light back onto the subject.

Notice the difference between the portrait above and this one. Simply by just changing my angle to the sun and reflecting a little light back at the subject, I achieved this photo.

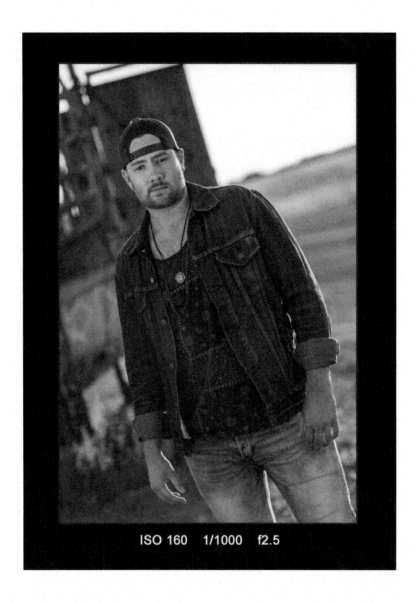

ISO 160 1/1000 f2.5

What I am trying to show here is that you have to work to get the results you desire. As you learn light, you will learn to harness it. This is where the real power of photography comes in!

The golden hour is excellent for street photography or candid people photographs. The quality of light is wonderful.

ISO 400 1/100th f4

For portraits, such as high school seniors and families, usually, you want to try and use a softer light whenever possible. This often means placing your subjects in shade, but the background can be quite harsh and much brighter than you prefer during the middle of the day or even during the golden hour.

I am always considering what it is I am trying to convey in a portrait. From that, I am able to consider how to use the light source.

For high school seniors or families, as an example, a softer light is usually best in order to give a softer and more emotional feel to the images. In this case, I used the golden hour but placed my subject in shade with a nice back light from the warm tones. This usually will require I use a soft flash or a reflector to get light back onto my subject.

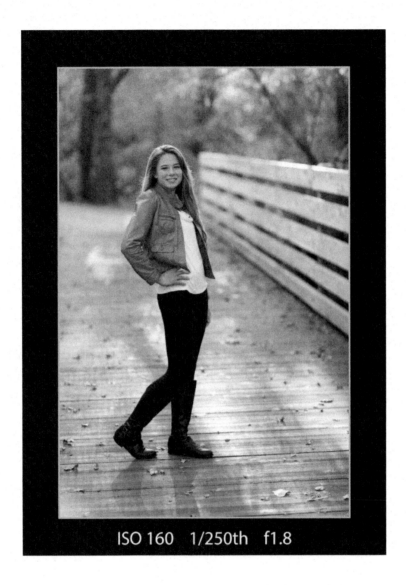

ISO 160 1/250th f1.8

In the family portrait below, by placing our subjects in the shade, but with the warm afternoon light behind, I had to use a flash to "fill in" the light. If you are not sure how to do this, there is an entire chapter on this in volume 1.

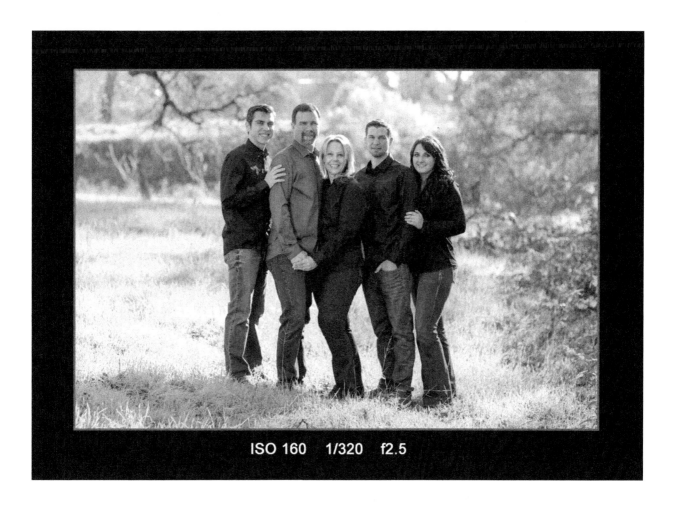

ISO 160 1/320 f2.5

Consider using an assistant to help you with the details, such as hair and clothing fixes. An assistant could also help you by holding a reflector, which can help bounce light back onto your subject. You will find this extremely helpful if your subject is backlit, such as above.

Take Action Assignment: The Golden Hour—Portrait

Preparation and Technique

- Select a subject to photograph. I recommend starting with an individual, such as a teenager versus a group or a small child because it will be easier.

- Start your portrait session two hours ahead of sunset.

- Use an assistant to help you with the details, such as hair and clothing fixes and holding a reflector if you choose.

- Be sure to have a minimum of 1/60th or higher of a shutter speed, depending on the lens you are using. Remember the rule that you should at a minimum have a shutter speed at least as high as the focal length of your lens. As an example, if you have a 70-

to 200-mm lens, the minimum for a handheld camera would be 1/200th of a second. Also remember your subject can move as well, so slow shutter speeds will not work in this situation.

- Use a shallow depth of field on individuals (which means small numbered f-stops).

- For groups, your depth needs to be greater so that your subjects do not fall out of focus from front to back. I recommend f8.

Wildlife—The Golden Hour

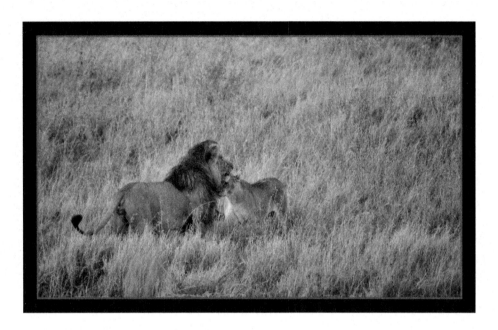

When I lead photographic tours in locations, such as Tanzania, and am fortunate enough to photograph such beautiful wildlife, I love the early morning glow and the deep warmth of the evening light of the golden hour.

During tours where we work with an animal trainer in locations, such as Moab, UT, as an example, we purposely plan our "animal photography sessions" during these times. Plus we take breaks during the midday sun.

Notice the rich, warm color tonality in these images.

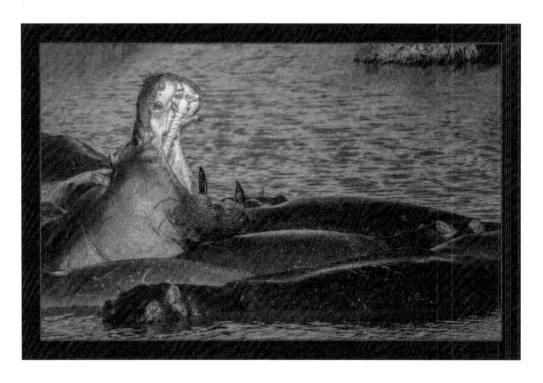

Midday Light

Obviously, with good reason, I have discussed in detail some of the optimum times for shooting and getting great light. With that said, it is not always possible to be in a specific place at a specific timeframe. We can do our best to plan it out and work to achieve it, but what about those times when it is just not possible? Does that mean it is not worth photographing? Absolutely NOT!

Although midday sun can produce harsh light, it does not mean we cannot get excellent results. The key with shooting at ANY time of day is knowing what to do with the light you are in. Harsh, defined light can give excellent details in your subject matter.

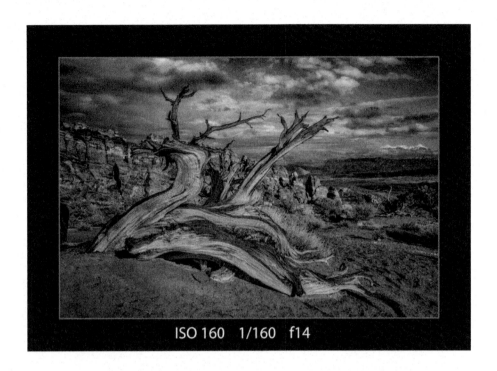

ISO 160 1/160 f14

ISO 400 1/320 f.56

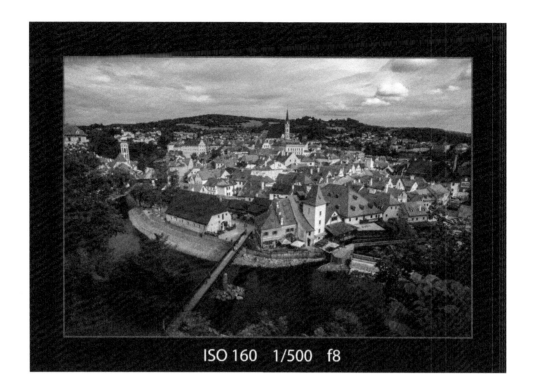

ISO 160 1/500 f8

When I am photographing during the midday hours, I do hope for a little bit of luck in getting clouds. I would much prefer my images to have something in the sky rather than just a straight blue midday tone.

Cumulus clouds always add an element of texture to the photographs.

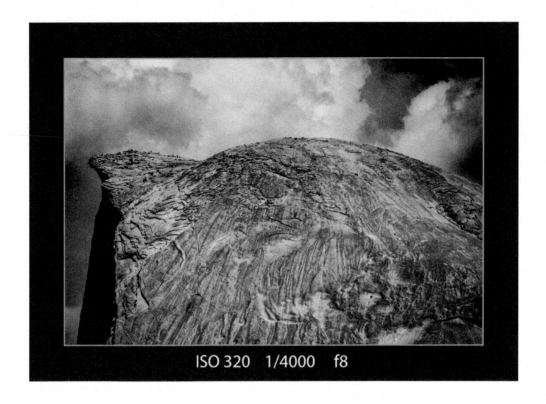

ISO 320 1/4000 f8

Take Action Assignment: Midday Scenic

Preparation and Technique

- Plan your photography session during the midafternoon when the sun is directly above.

- Photograph and use the harsh light to create dramatic contrast in buildings, landscapes, or animals.

- Hand-hold your camera and enjoy just shooting free-form with no tripod. Be sure to have your shutter speed high enough for hand-holding. Refer back to volume 1 if you need help with your settings.

I have also found that if you are dealing with harsh shadows and harsh light that finishing your image as a black-and-white really works well in those conditions. I tend to feel that with that harsh light, black-and-white tends to be a more powerful way to go in the image. This is a generalization, but one I have found I prefer much of the time, such as in this image below of this group of hippos in Tanzania, Africa.

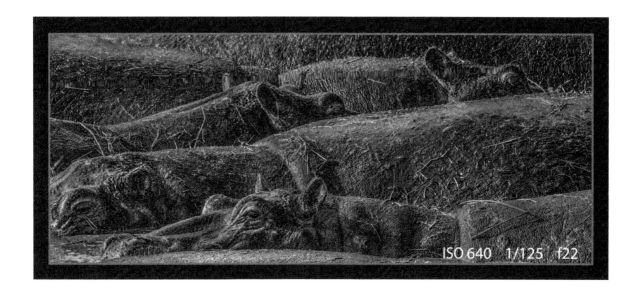

ISO 640 1/125 f22

When photographing in the middle of the day, it is still quite possible to locate "soft light." You just have to look for it.

This vase was in a back alleyway in Folegandros, Greece. The alleyway itself was actually quite harsh with light and shadow, so in and of itself, it would not have been a very nice photograph. However, I noticed this vase was sitting off to the side of this little, rustic building.

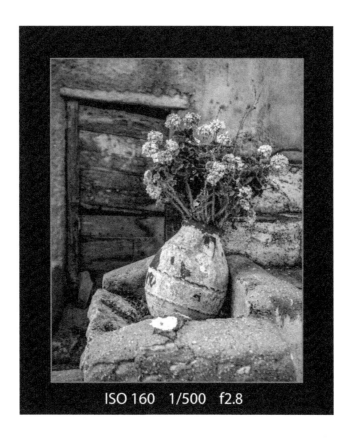

ISO 160 1/500 f2.8

What created a beautiful, soft, and dimensional light (highlight and shadow) was the fact that the sun was reflecting off of a white building back onto to the vase that was in the shade. If you notice, the left side of the vase is brighter, and that is from reflected light off of a white wall. Once again, it is not always about the light itself, but WHAT the light is doing. In this case, this was taken in the middle of the day but looks like a soft morning light.

Take Action Assignment: Midday Soft Light

Preparation and Technique

- Plan your photography session during the midafternoon when the sun is directly above.

- Find a subject in soft light in the middle of the day. Look for overhead patios, buildings, and whatever else you can find that help create soft light on your subject by blocking the midday sun.

- Be sure to keep the background in evenly lit light as well. Avoid your subject being in the soft light but your background being extremely bright. Otherwise, the background will be a distraction.

Tip

Below is an image of Tunnel View in Yosemite, once again. Notice, however, that this time, there is a large shadow being cast across the valley floor.

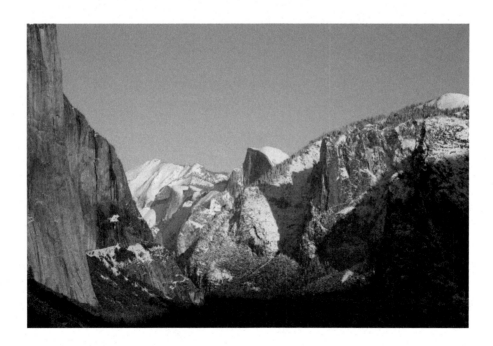

This is an example of where I would choose to isolate areas in the scene to photograph that have even light rather than shoot the whole scene with the distraction of the harsh shadow.

El Capitan is off to the left. In this situation, I knew that since El Cap was well lit, the shadow itself might create some depth and contrast in the image yet not become a distraction. By isolating a portion of the above scene, I photographed El Capitan and used the shadow to actually help increase a feel of depth and dimension.

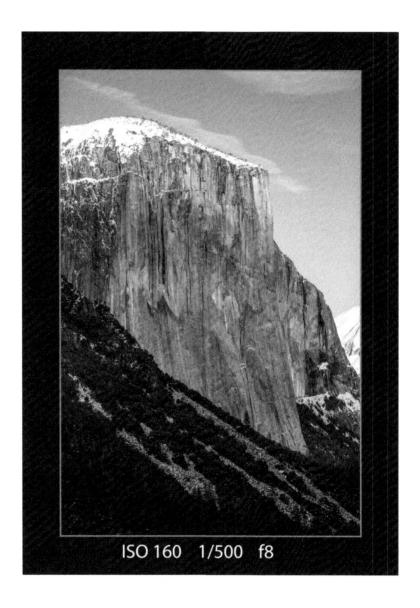

ISO 160 1/500 f8

In photography, you must realize that you have to work with the elements you have at your disposal. Sure, I will still take the image, such as Tunnel View above, just for a memory. However, by isolating El Capitan, I came up with an excellent image. Do not be afraid to shoot the entire scene, but then isolate!

Stormy Light

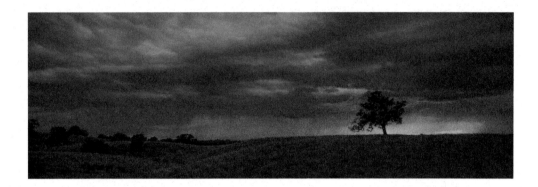

As someone that leads photographic tours around the world, in all of the various seasons, I cannot count how many times people have asked me if we were still going to go out to shoot because it was raining.

I want you to realize something that is so important. I cannot emphasize it enough: when it is raining or stormy, this may very well give you the opportunity to get your most impactful images you ever create of landscapes.

The image above is an example of just that. This "Lone Oak" is literally five minutes from our home. I have driven past this location thousands of times and have never prior, nor since, seen anything like this. This was a moment when Adam Furtado, who instructs for us, called me after being at our place, telling me to get out there and shoot.

To be honest, I was completely exhausted, having taught for three ten-hour days straight, and I almost didn't go. However, I am certainly glad I made the effort and did. To this day, this is one of my favorite images I have ever photographed, and it is one of my highest awarded images as well. No matter how great you may be in software, such as Photoshop, an image like this cannot be "made" without the beautiful light that was already on hand.

The reason this is the case, is not because of the light that is happening during the rain, but it is because of the light that happens in those few moments in between storm clouds and breaks. The light that can take place is some of the most dramatic light in all of landscape photography!

If it is stormy, grab your camera and get out there! I know, I know . . . I can hear it already—"But, David, it's cold and wet outside." Yes, it may be. Yet, it also may be a lost opportunity if you do not get out and shoot!

First, let's talk about your gear and protecting it. I simply recommend that you purchase what is known as a camera Rainsleeve. These are inexpensive plastic wraps that will cover your camera and still allow access to work the controls.

If you do not have a Rainsleeve on you, a simple plastic bag can be modified to cover your camera. If you are traveling, hotel shower caps work great!

When it comes to working in stormy weather, I will not just stand in the downpour and shoot. I wait for the right opportunities. I am not afraid of a little rain or mist.

It is when you see the clouds breaking on the horizon that you need to be ready to go. The moments you have may only last a minute or two to capture spectacular photographs.

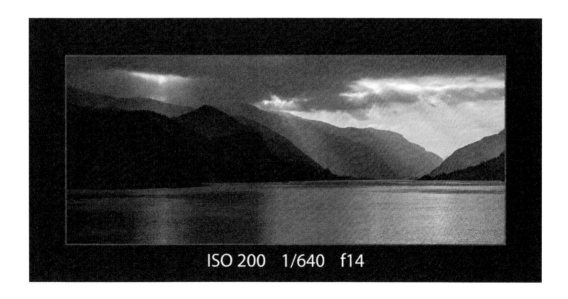

ISO 200 1/640 f14

This image of the Hood River on the Columbia Gorge in Oregon happened as we were driving to a friend's home for dinner. It was a moment when everything just happened, and I had to pull off the side of the road and capture it. It lasted no more than a few minutes.

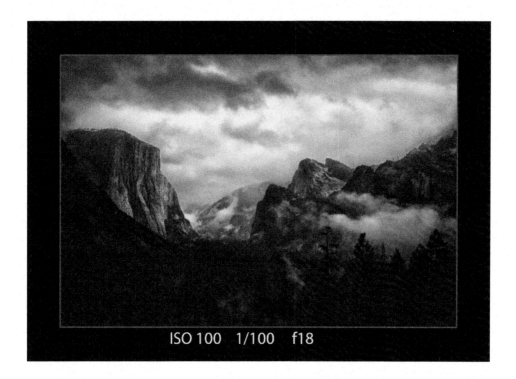

Here is beautiful Tunnel View in Yosemite, one more time. This was taken in the middle of the day in the middle of a storm. Notice how completely different it is from the other Tunnel View images I included earlier in the book.

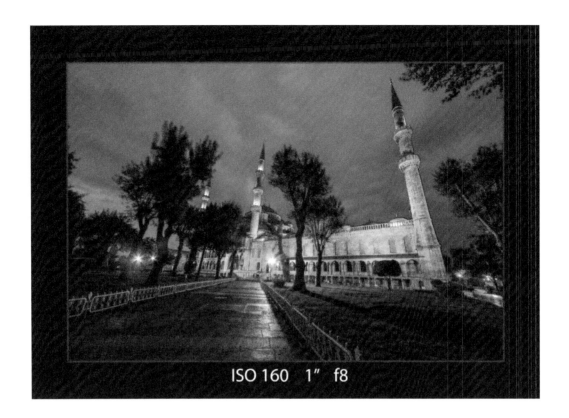

ISO 160 1" f8

Here is a stormy night in Istanbul. The rains came, so the tourists left. For me, this was the perfect opportunity to combine a stormy night with twilight and create an image tourist-free!

So why am I sharing these stories with you and not just the images? The answer is that I could easily just tell you the settings I used and leave it at that. However, I really want you to understand that as someone wanting to create amazing photographs, more often than not, you have to put in an effort to make it happen.

It may mean getting up early or dealing with a storm or staying out late or driving a few hours. Yes, sometimes it may not pay off, but when it does, it is so worth it. I'd like to use the analogy of fishing, once again. You may not always catch the big one, but even when you don't, the experience of just being out there is far greater than never having gone at all.

Yet, when you do get the great fish or in this case, the amazing photograph, it is a feeling that is not only wonderful, in the case of an image taken—it is a moment captured forever that you will remember and others will enjoy.

Sometimes a little luck is involved, just like catching the big one. But if you never make the effort, no amount of luck will afford you an amazing photograph. You must take your newly acquired skills, knowledge, and whatever photographic gear you own, and make the effort to go out and create an amazing photograph.

Take Action Assignment: Stormy Light

Preparation and Technique

- Shoot during a stormy day.

- Do NOT shoot if there is a dangerous situation, such as lightning, close by.

- Twilight, stormy nights can be incredibly beautiful. Use your tripod and do your twilight settings. If windy, be sure your tripod is totally stable.

Add-On Story: January 27, 2016

I was writing this section of the book today from a hotel room in Auckland, NZ. This was the day prior to our clients' coming in for the beginning of our tour here. It had been raining much of the day, and having a deadline for this book to get to the editor, I decided to take the entire day and write.

As I was writing the last part of the section about effort and storms, I thought to myself, "You really should go shoot tonight and practice what you preach!" With that, Ally, the rest of our team, and I decided to go out and shoot at twilight the Auckland cityscape.

Yes, it was worth the mile walk, the ferry ride, and the chance of not getting anything to come away with this. The effort was put forth, with the knowledge I have and a bit of luck, as well with the clouds and break in the storm. Now, I have an image to cherish. This image was shot at ISO 160, f8, for thirty seconds.

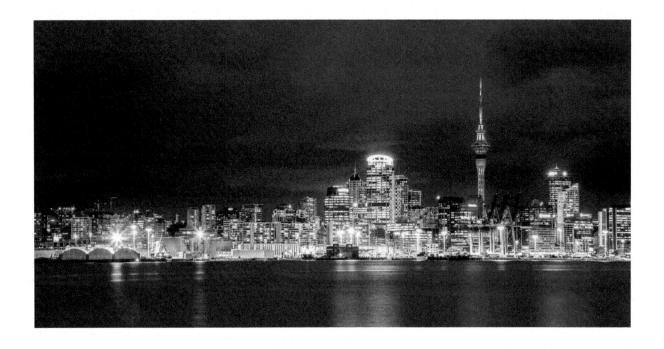

Moonlight

As a photography educator, it is always really exciting to me when I am able to show people the abilities to photograph in situations they never thought possible.

Shooting at night and doing extreme long exposures is one of those times. You need to remember that photography is all about light. Just because it does not seem like we have much light on hand, for example, as during a sunny day, does not mean we cannot accumulate enough light for a photograph.

If you consider the moon, it is lit, but what is it lit by? The answer—the sun. So then it should stand to reason that we have light. It may just not be as bright as what we have during the day. However, as mentioned, we can accumulate light on our sensor over time by keeping the shutter open.

This image of El Capitan was taken during a full moon. The moon was directly lighting the mountain and gave plenty of light. I just had to make sure I had a long enough exposure to accumulate that light to the sensor. This was taken for thirty seconds.

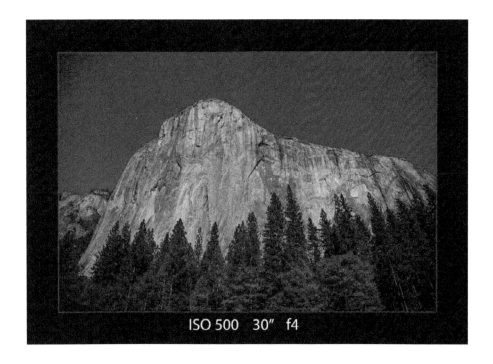

Notice the ISO was at 500. I could have opened my shutter longer using the "bulb" setting and lowered the ISO. However, in doing so, I would have had more movement in the stars than I wanted. Thirty seconds is about the longest you can go before you start seeing highly noticeable movement in the stars.

Moonbows

Moonbows, or lunar rainbows, are natural phenomena that take place in a few locations around the world when conditions are just right.

Just as a rainbow can occur as the sun hits mist, a moonbow can occur the same way. In order for it to happen, there has to be a full moon that lines up and lights the water just right. In Yosemite, this only occurs two to three times a year.

I have personally planned tours around the full moon to photograph Lower Yosemite Falls in hopes that we can catch the moonbow. If the weather cooperates, it can happen and be truly magical. Again, conditions, such as no clouds, enough water flow, wind, and other factors, all come into play as to whether you will see it or not.

I actually find that this is really awesome because once again, it takes all the predictability out of it, and you are at the mercy of nature. You can do all the planning and preparation, but if nature doesn't cooperate, you will not get your images. However, if the conditions are just right, you will have an unforgettable moment and photograph!

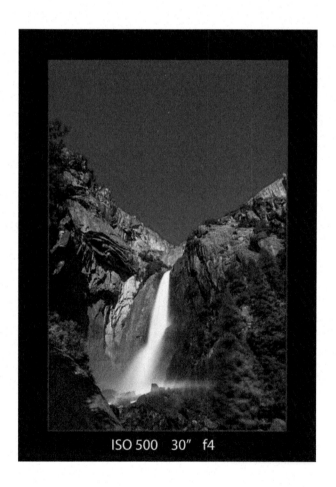

ISO 500 30" f4

Turn Night into Day—Moonscapes

During a night session, you can literally make nighttime look like daytime. By setting your camera to the "bulb" setting and using a cable release that locks, you can set your shutter speed open as long as you like.

As an example, if you are photographing a landscape and leave the shutter open for a few minutes, you will have accumulated enough light to actually make your image look like it was taken during the midday! The more moonlight you have, the easier it will be. With that in mind, a full moon is a great time to shoot moonscapes!

Take Action Assignment: Moonscapes

Preparation and Technique

- Shoot during a full moon.

- Use your smallest numbered aperture/f-stop opening.

- Use your tripod and set your ISO to 1600 to start.

- Use "bulb" setting (just past thirty seconds or the B on your mode dial).

- Start with a thirty-second exposure to gauge your results.

- Using a cable release and timer, continue to do longer and longer exposures to get various results.

- Try exposures as long as you like and turn night into day!

- Remember your tripod must be totally secure.

Shoot the Moon

Most people when they want to photograph the moon directly are misled in thinking that they need a really long exposure or a high ISO. The reason people think this way is because they think that with nighttime, you usually need a long exposure, which much of the time is correct.

Yet, when you are photographing the moon directly, you must realize that the moon is full of light. The moon is lit by the sun and is fairly bright. Also, if you were to do a long exposure, since the Earth rotates, the moon will have an oblong shape instead of what you really want to accomplish.

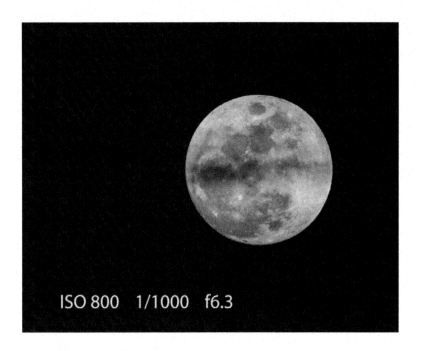

ISO 800 1/1000 f6.3

The best way to photograph the moon is with a long telephoto lens. A 300-mm lens at a minimum is best. You will want to set your ISO to 400 or 800 to start. Then open your aperture to its largest opening (smallest number), and adjust your shutter speed accordingly for the exposure. I recommend a tripod so that if your shutter speed is slower than the recommended hand-holding speed of a minimum of the focal length of your lens, you do not get camera shake.

I find that shooting at about ISO 400 or 800, f5.6, and a shutter speed of about 1/640th of a second seems to be a great.

If you find your image is too dark, raise your ISO a little at a time to get what you need.

Take Action Assignment: Shoot the Moon

Preparation and Technique

- Shoot during a full moon.

- Use your smallest numbered aperture/f-stop opening.

- Set your ISO to 400 to start.

- Start with 1/400th of a second and adjust from there.

Stars

Photographing stars properly requires being in a location without light pollution from city lights, as an example. You will, once again, need a sturdy tripod for long exposures, a cable release, and of course, a clear night! It is also going to be an advantage to use a lens with a small number (wider opening f-stop).

For star photography, typically anything longer than fifteen to twenty seconds in your exposure, and you will start to see movement. This happens as the Earth is rotating. Due to this, use a wide-open aperture (as wide as your lens allows) and a bit of a higher ISO. If you use a lower ISO, it will require a longer exposure, which in turn, causes movement in your images of the stars.

This image below of the Milky Way and thousands upon thousands of stars and galaxies was made possible by being in one of the least light-polluted skies in the world in Mt. Cook, NZ.

Notice the shooting star!

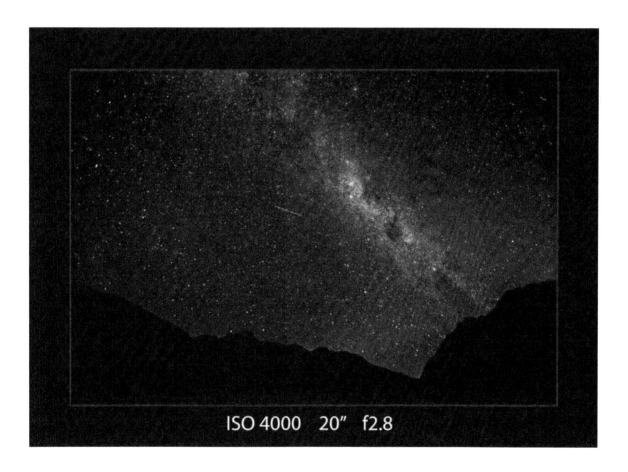

ISO 4000 20" f2.8

Take Action Assignment: Photograph the Stars

Preparation and Technique

- Go to an area with no light pollution during a dark sky (small moon).

- Use your smallest numbered aperture/f-stop opening.

- Set your ISO to 2500 to start.

- Start with a 15-second exposure and adjust from there. The lens must be set to manually focus.

- Use "infinity" for focusing. Infinity is indicated on some lenses by a symbol that looks like a sideways eight (∞). If your lens does not have this, it is no problem. Prior to the evening, test your lens and find where it is sharp for long distances. Simply focus on an object far off in the distance. When the lens is focused, mark that spot on the camera either with a marker or piece of tape.

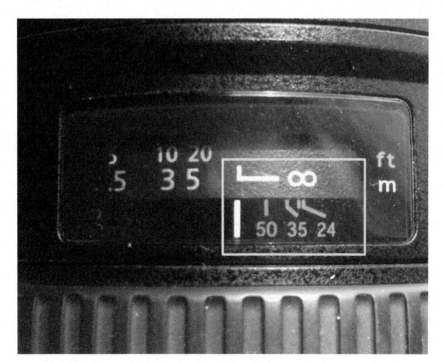

Above, you can see the infinity marking on a lens.

Star Trails

I know what many of you are thinking, so I will answer it now. The question then comes up in regards to star trail photography. As much as I love what it looks like and does, this is not something I personally have done much of or am an expert at. So I will not go into detail on how to accomplish the best result as there are others out there that are far more knowledgeable than me. Check out www.photorec.tv

With that, I can tell you that to get star trails, some photographers leave the shutter open for extreme amounts of time, four hours or longer. This is not an uncommon way to accomplish star trails. This is done by pointing your camera at the North Star in the Northern Hemisphere or the Southern Cross in the Southern Hemisphere. As the Earth rotates, the star trails then are recorded.

I also know that photographers that do a lot of this type of photography prefer to shoot many images and then combine them altogether into one image using software. This is to avoid your sensor getting hot, and also it reduces the amount of digital noise in the image.

This seems to be the preferred method as you can do as little as twenty images in one night, taking a photograph every few minutes, and then you stack them to get the results you need. Toby of Photorec.tv created this stunning image below with this technique.

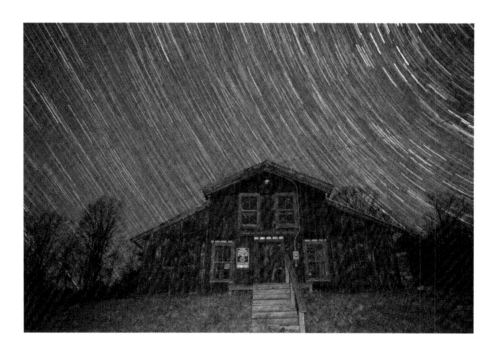

Section Three

Creative Ideas

In this section of the book, I am going to give you the tools and techniques needed for many various photographic creative ideas you may want to explore. These are all based around light and working with the light of the moment. After all, it is light that allows us to create photographs!

Sun Flare

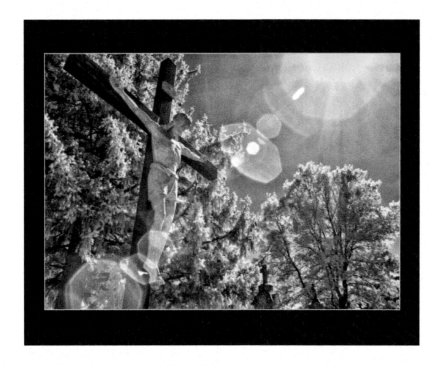

People tend to be fearful of having sun flare in their images. I agree that it can be a distraction and has ruined many otherwise excellent photographs. However, if used correctly, a sun flare can enhance and add dramatic effect to your photography.

The key to using sun flare is to know when to use it—and to not over-use it! My wife, Ally, is awesome when it comes to being artistic with flare. These are all her images.

She will use the flare very specifically in patterns that either lead you directly to your subject or play graphically within the image.

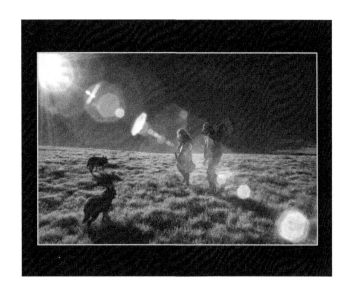

Take Action Assignment: Create an Image with "Flare"

Preparation and Technique

- Plan your photography session during the later afternoon when the sun is lower on the horizon.

- Use a wide-angle lens.

- Use a higher f-stop, such as 16 or 22. Due to the way the optics work within wide-angle lenses, you will have an easier time getting flare that is not just a bright hotspot.

Starburst

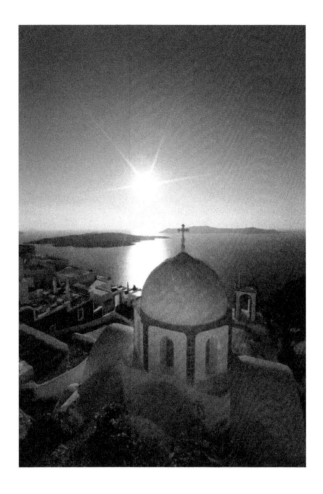

Based on the same idea of using the sun to get a flare, we can also create another effect known as a starburst. The sun starburst can be achieved to create some nice added dimension to images.

Just like with the sun flare in images, the key is to not over-use it. However, if you find yourself in a situation where you are facing the sun, this is an excellent way to use it in your landscape images.

In order to create this effect naturally, you need to use as small of an opening in your lens as the lens will allow. An f-stop of 22 or greater is preferred, and you will also find that by using a wide-angle lens, you will have more success.

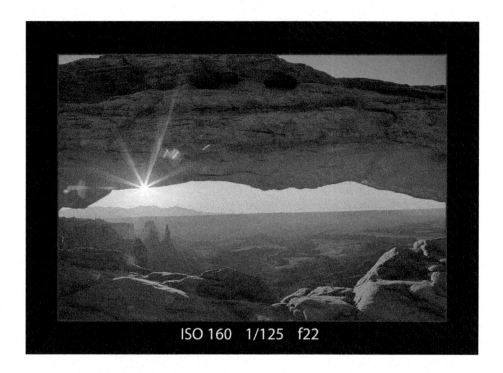

ISO 160 1/125 f22

Use a portion of your image to slightly block the sun, such as in the image above. This helps so that the light is not so bright at you.

As an experiment, looking at a bright light (not the sun itself), take your hand over your eye and make a tiny opening to look through. You will notice that the light starts to "burst." This is exactly what happens in a lens and why we need a small opening (larger numbered f-stop) to achieve success.

Take Action Assignment: Create an Image with a "Starburst"

Preparation and Technique

- Plan your photography session during the later afternoon when the sun is lower on the horizon.

- Use a wide-angle lens.

- Use a higher f-stop, such as f22.

- Use part of your image to slightly block the sun to help keep the light from being too bright in the lens.

The Art of the Silhouette

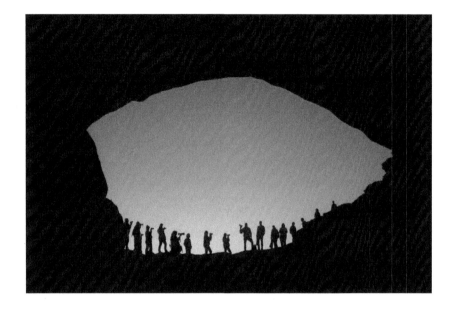

Silhouettes are a great way to play with light. These images are not that difficult to create, but like many things, it is just a matter of someone showing you how and explaining it in simple terms.

When creating a silhouette, there are a few rules to follow to ensure getting optimum results.

First, make sure that you place your subject directly in front of a brilliant light source. The idea is that you are going to be exposing your image for the light source—and NOT for your subject.

If you were to expose for your subject, the result would be a washed-out, overexposed background. In this case, we want the subject completely dark. In order to do so, set your camera on manual settings and expose for the background.

I would recommend starting at an ISO of 100 and an f-stop of f11 or f16. This is because we know that we want the subject dark anyway, so a starting point of a smaller aperture opening to begin with makes sense. Now, using your light meter, align it to center by moving your shutter speed.

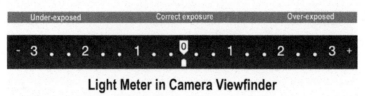

Light Meter in Camera Viewfinder

Look to see what side your Plus sign and Minus sign are on.
Plus side is over-exposed and minus is under-exposed.

Take a look at your results. If your subject is too light, simply make your shutter speed FASTER, which then does not allow as much light in. Continue to do so to get the results you are looking for. At this point, do not worry if the light meter is at the underexposed area. You are, in fact, underexposing your main subject. This is what you want.

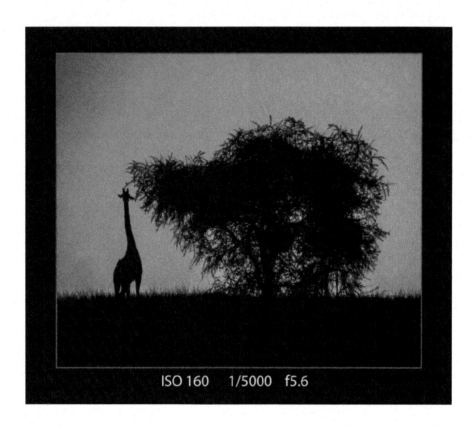

ISO 160 1/5000 f5.6

When photographing a silhouette, it is also very important to look at how the background or any areas of black are showing. If you are not careful, the silhouette can look very "blocky" with the subject blending into other areas. You really want the silhouette to have proper definition between areas, such as background and other body parts, for example.

In the image below, you can see how our subject blended into the background and is not well-defined.

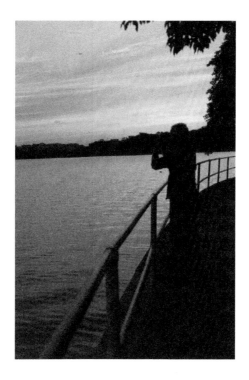

Now, by simply changing our camera angle, we get a much better result!

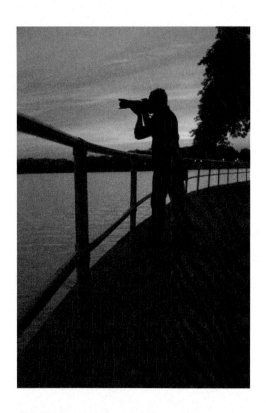

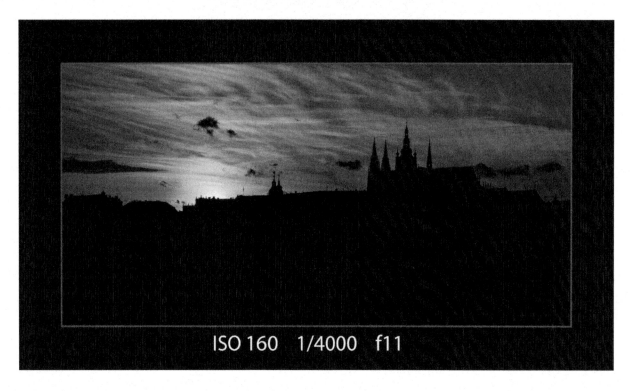

ISO 160 1/4000 f11

Take Action Assignment: Create a Silhouette

Preparation and Technique

- Place subject in front of a bright light source, i.e., a sunset.

- Expose for bright background (NOT SUBJECT).

- Use an ISO at 100.

- Set aperture at f11 or f16.

- Adjust the shutter speed faster (less light) to get the subject darker.

- Make sure there is a distinct separation in the silhouette areas.

Backlight

I love photographing much of my subject matter back-lit. Not every subject will be better back-lit, but I find that animals, foliage, and even people are photographed very nicely when back-lit.

What exactly do I mean by "back-lit"? It is exactly as it sounds—your light source, such as the sun, is behind your subject. You have to be very careful of the angle because if it is too direct, it will be difficult to get a good exposure.

ISO 250 1/125 f22

We are not looking for a silhouette in these images, but rather a light that "rims" or "highlights" the back of the subject nicely. This helps separate the subject from the background as well.

Foliage tends to be much stronger photographed with a backlight. When the sun is at an angle, during the golden hour, as an example, shooting directly at your foliage front-lit may be nice and work well.

However, if you take the same foliage, placing yourself in a position where the light is coming from behind, you will notice there will seem to be much more texture and dimension to the image.

You may find it easier to change your metering to the spot-meter setting in order to isolate the subject matter you want to obtain your exposure from (see "Metering").

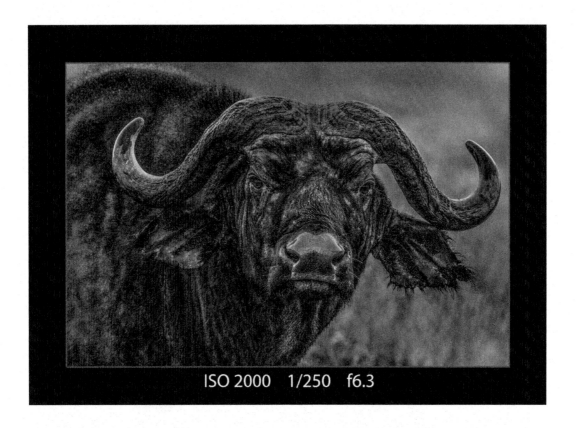

ISO 2000 1/250 f6.3

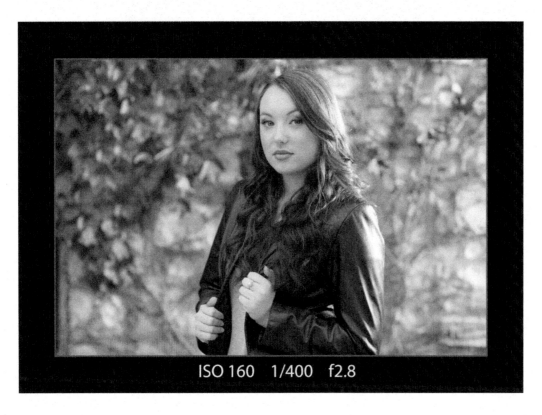

ISO 160 1/400 f2.8

Take Action Assignment: Backlight

Preparation and Technique

First Assignment—Foliage with Backlight

- Use a lens shade to help with flare.

- Photograph foliage or plant life with light from behind.

- Expose for subject (NOT background).

Second Assignment—Person with Backlight

- Use a lens shade to help with flare.

- Photograph a person with light from behind.

- Work to find a location where the person is not completely in the sun.

- Expose for subject (NOT background).

- Place yourself in the shade to help avoid flare as well.

Reflections

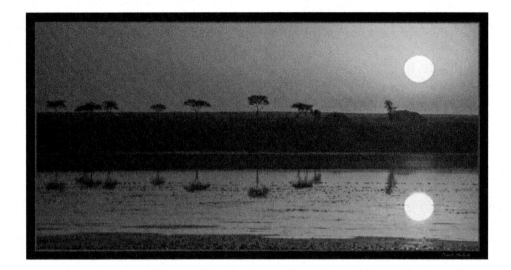

Reflections in photography are not only beautiful to photograph, but they will also create a completely different "feeling" to the scene. I love photographing and capturing reflections.

One of the challenges in doing so is that the exposure value of the reflection, many times, is different than the exposure value of the actual subject. There are a few ways that this can be approached.

If you recall in volume 1, I discussed the fact that you do not want to "blow out" your highlights to where they have no detail. In photographing reflections, it is very easy to do just that. The solution is to make sure that your actual subject is properly exposed. If that means the reflection is too dark, we can pull out the details later in post-production work in Photoshop or Lightroom.

This is important because we cannot fix completely blown-out areas of photographs; however, we can pull out shadow areas. This is where a split or graduated ND filter can help tremendously (see previous section about filters).

One thing about reflections is that you can see them in many forms. The obvious, of course, is in water. However, be sure to look around for reflections any time you are out photographing.

Buildings, windows, and puddles all offer interesting reflections of subject matter. You just need to take time to look for reflections even when it may not be obvious they are around.

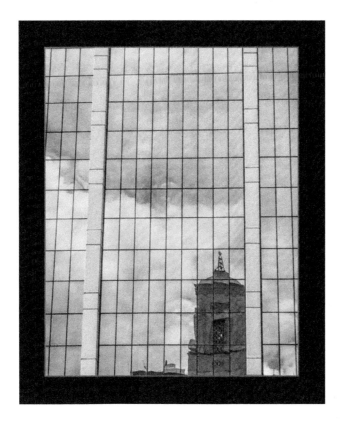

This image is a reflection of light off the fall color leaves.

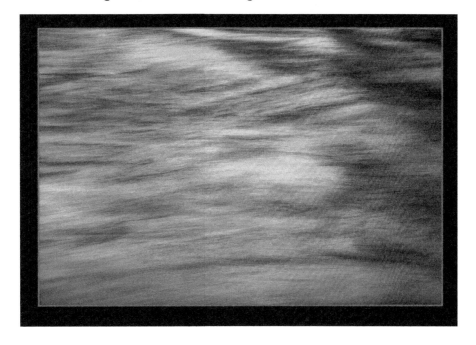

If you are photographing a scene, such as this one below of the Palace of Fine Arts in San Francisco, you may not see the reflection with your naked eye as much as what you can capture in a photograph.

If there is movement in the water, the reflections do not show up as well. Here, as an example, the water had a lot of ripples due to the wind at the time. However, by slowing the shutter speed down, using a tripod, and doing a twenty-second exposure, the water movement goes smooth, so now the reflection shows up better than what your own eye can even see.

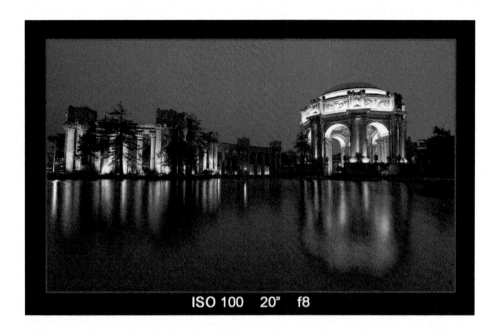

Take Action Assignment: Reflections (Several Types)

Preparation and Technique

- Photograph a reflection using water, such as a lake.

- Photograph an "unseen" reflection, a situation where the reflection is not obvious to everyone around, such as in a window or building.

- Photograph a reflection of light and color as a detail. Focus in on the subject for an abstract image.

- The setting will be based on your scenes.

- Use whatever "tools" necessary in your bag.

Water Movement

Photographing water features, either man-made or created by nature itself, often allows you as a photographer many different creative options.

I love the feeling of slowing down the shutter speed in order to get the silky smooth look of a waterfall. On the other hand, this can sometimes be overdone. Be sure to also work to freeze the nuances of the water itself as it moves, shimmers, and "dances" off of rocks or boulders.

Slowing Down the Water

When doing this type of image, the key to success is using a long shutter speed. Based on the actual power of the water itself, your results will vary. In other words, if you are photographing a stream, it may require a much longer exposure to get that look of smoothness, versus a thundering waterfall in Iceland.

One other note is that you can do this with any type of water photography. This image below was at the ocean as the waves were crashing in. My aim was to create a very mystical type image.

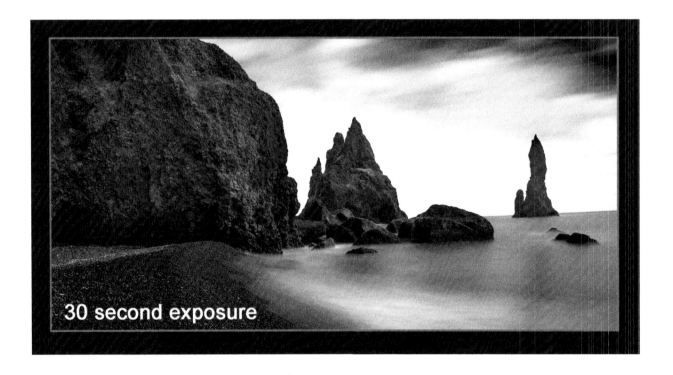

30 second exposure

The primary issue most people face in doing this type of photography is the fact that when doing a long exposure in the daytime, so much light is coming in that it is almost impossible to not overexpose the image.

The solution—use an ND filter and a large numbered f-stop. The larger f-stop, such as f22, means a small opening in the lens reducing how much light is coming in. Then, by placing an ND filter, such as a #8 or even a #10, that is dark over your lens, you will be taking away even more light, which forces your shutter speed to need to be open longer to create the exposure. The longer you can go, the more smoothness you will obtain in your water.

One note about using the really dark ND filters. These filters are so dark that the lens cannot focus through them. You need to focus on your subject and then place your lens to manual focus, so it will not keep trying to focus, and then place your filter on. If you do not do this, the lens will keep trying to focus, but because it is so dark, it will not be able to see through the filter and obtain the needed focus.

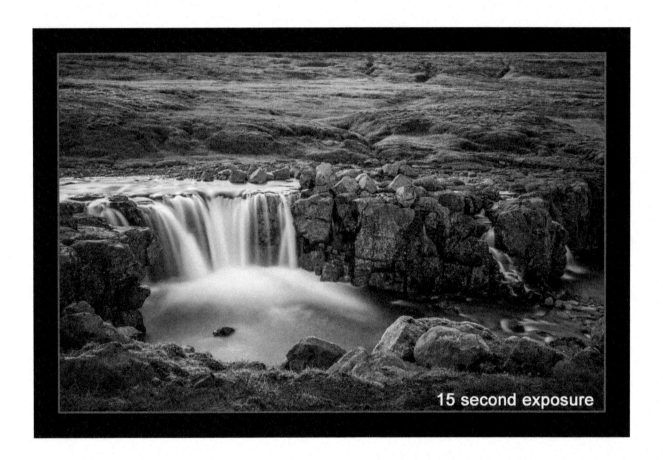

15 second exposure

Take Action Assignment: Slow Down the Water Movement

Preparation and Technique

- Choose your subject, such as a waterfall, stream, or other moving water feature.

- Use a tripod.

- Set your ISO to 100.

- Set your aperture to f22 or higher if your lens will allow.

- Align your light meter using your shutter speed.

- If your shutter speed is still too fast to get the slow feeling of movement in your image, come back when it is darker OR place an ND filter over the lens.

- Use a cable release or self-timer to make sure you do not get camera shake.

- Use your light meter with the ND filter, but if the image is too dark, just judge by what you like. Simply make the shutter speed longer and longer to get the exposure you need.

Capturing the Speed of the Water (Dance of the Water Drops)

When out teaching or photographing water subjects, one thing I always try to get across to my students, or accomplish myself, is a variety of images of the same water feature but with various nuances. I might slow things down and go for the silky smooth look, but I am also not afraid to use a super-fast shutter speed and try to capture every little drop of water dancing off a rock.

One of the beautiful things about photographing water is that each image will always be unique. Every image will always have its own special characteristic based on all the factors at play, for example, the way the light hits the water, how fast the water is moving, if wind catches the water as it goes over a fall, and much more.

This allows you as a photographer a moment to sit and photograph the same subject over and over, yet you get completely different nuances and results to your images!

To capture what I like to call the "dance of the water drops," you need to have a very fast shutter speed. Take your shutter speed up as fast as it can go, such as 1/4000th of a second. Now, take your aperture and align the needle in your light meter. If you find that you have taken your aperture to the smallest number your lens will allow and you still do not have enough light, raise your ISO to get what you need.

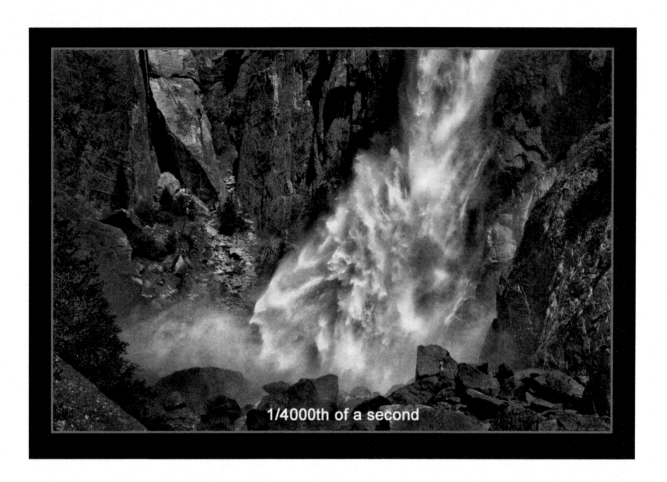

1/4000th of a second

Take Action Assignment: Stop the Water Movement

Preparation and Technique

- Choose your subject, such as a waterfall, stream, or other moving water feature.

- Set your shutter speed as high as it can go, i.e., 1/4000th of a second.

- Align your light meter using your aperture/f-stop.

- If your aperture is completely open (at the smallest number) and you do not have enough light, take your ISO higher. You can also use auto ISO if necessary.

- Use the continuous shutter feature to shoot bursts of images so that you can capture exact moments of water "dancing off the rocks."

Panning

Panning is a way to make your subject look like it is moving really fast. Sometimes your subject really is moving fast, so panning gives a sense of motion to your image.

If you are photographing a moving object, such as a car or child running, as an example, consider using this technique to create that sense of movement and motion rather than just stopping the action totally.

When you are moving with your subject, the background, which is stationary, will be blurred due to your movement. This gives the sensation of speed and motion blur.

- Panning is moving in <u>synchronization with your subject as it moves</u>.

- To depict movement, the shutter must be at least 1/100th of a second or slower.

- The slower the shutter speed, the harder it is to keep your subject sharp.

- A slower shutter will depict more feeling of movement.

- For very fast subjects, such as racecars, try starting at 1/100th of a second.

- For slower subjects, start at 1/40th of a second.

When doing a panning technique, rather than working to handle your exposure constantly, I recommend using "shutter priority," choosing your shutter speeds, and letting the camera choose your aperture for you. Doing this will allow you to focus on your speed and what you are trying to accomplish rather than the perfect exposure. If you need to, it is okay to use auto ISO as well. The idea is to be able to really concentrate on what you are trying to accomplish rather than being bogged down by all the settings.

In this image of the roller coaster below, notice how everything is stopped. Although we know they are on a thrill ride, the photograph doesn't show anything that would suggest that. In fact, it as if they are just "stopped" totally, and that does not convey much "speed" or excitement in the image.

Notice in this next image below how much more excitement the photograph tends to show. Plus, there is a real sense of "speed" taking place!

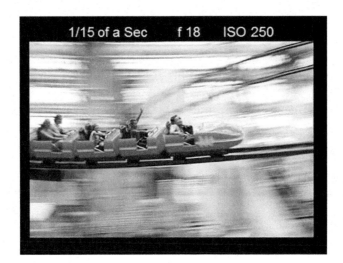

In this first image of the swinging chairs, I forgot to pan. This resulted in an image where the subjects were totally blurred!

By using the same settings but moving with the subjects, I was able to create this movement on the ride that depicts a much better feeling of fun and emotion.

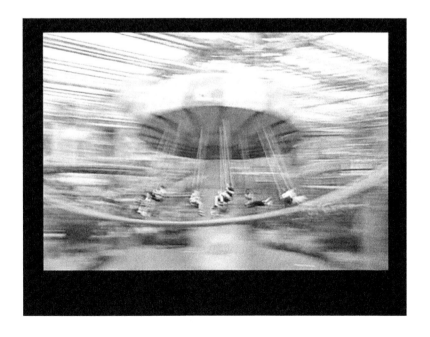

Another way to depict movement is in subjects that are spinning. In this case, rather than pan in a horizontal movement, you can rotate the camera in a circular motion.

Go against the direction that the subject is moving. SO if the direction of the subject is going clockwise, you should rotate counterclockwise. The faster you rotate, the more feeling of movement will be depicted. Remember to slow your shutter speed down!

In this image below, I stopped the action completely.

Now by slowing the shutter speed and rotating the camera during the exposure, this photograph was created.

Other ways you can depict motion are to use your zoom during the exposure. As the shutter goes, zoom your lens out and see what you can create!

Take Action Assignment: Create Motion Movement

Preparation and Technique

First Assignment—Photograph a Moving Car

- Set your mode dial to "shutter priority" (Tv or S).

- Set your ISO to "auto."

- Start with a shutter speed of 1/40th of a second, and "pan" with the car as it moves by.

- Keep doing this while adjusting your shutter speed until the desired result is obtained.

Second Assignment—Photograph a Child Running

- Do the exact same steps as above, but notice you may need to slow the shutter speed more as the speed of your subject is different!

Third Assignment—Zoom Motion

- Do the same steps as above, but use a zoom motion on your lens during the exposure.

Fireworks

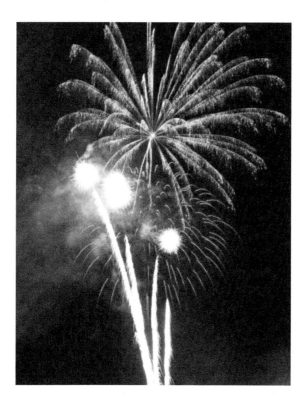

Photographing fireworks is all about timing! When photographing fireworks, you do not have much time to get it right, you only have a few minutes before the show is all over, and you have to wait until next year!

My hope is that this tutorial will get you on your way to capturing excellent fireworks photographs at your next attempt.

There are two ways that I will photograph fireworks. Either way will require a tripod and a cable release. I also recommend using a medium-range focal-length lens. If you have too wide of a lens, the fireworks will be small, and if you try to zoom in tight, you will find it is very difficult to capture and also focus.

The first thing to do in either technique is to get your focus set. You will need to manually focus because if on autofocus, the lens will constantly be trying to focus, so you will miss your shots.

If your lens has the infinity sign (∞), that is a great way to start the focus process. Set your camera lens to manual focus and align the infinity symbol with your line on the lens as in the example below.

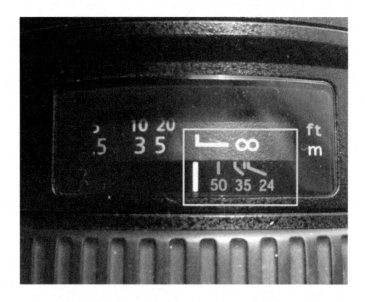

The idea is that any object thirty feet or farther will be in focus. You may have to make minor adjustments, but chances are this will nail it.

If the lens you are using does not have this guideline, simply focus on an object at least thirty feet away manually, and start there when the fireworks start going. Again, you may have to make minor adjustments, so be sure to check your focus after the first few images!

In technique one, set your shutter speed to four seconds and f5.6 for the aperture. Your ISO can be set to 100. Remember, even though it is night, the subject (fireworks) is extremely bright! As the fireworks go, depress the shutter with your cable release and time the six-second exposures as best you can for the burst and trails of light shooting up.

In technique number two, set your camera to the "bulb" setting. This will be located by either going past thirty seconds on your shutter speed OR as a "B" on the mode dial. Your ISO can still be at 100 and your aperture at f5.6.

Take a black piece of poster board and hold it over your lens. Depress the shutter and LEAVE THE SHUTTER OPEN. As a burst takes place, take the poster board away from the front of the lens allowing the burst to be captured. While keeping the shutter open, in between bursts, place the board back over the lens. In this way, you can capture several firework bursts in one single image!

Do this for as many bursts at a time as you like and have fun experimenting! If you find your images are too bright, simply take the aperture higher (smaller opening).

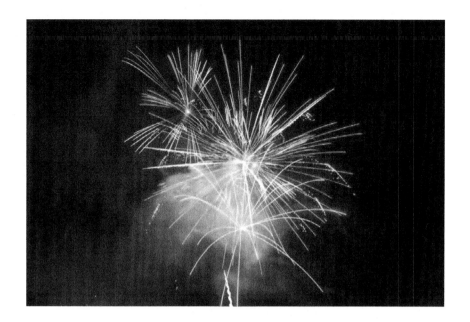

Take Action Assignment: Fireworks on July 4th or New Year's Eve.

Preparation and Technique

- Use a tripod.

- Use a cable release with a lock-up to keep the shutter open.

- Use a medium-range focal-length lens, such as a 24- to 105-mm lens.

- Manually focus using the infinity technique.

- Set your ISO to 100.

- Set your aperture/f-stop to f5.6.

- Set your shutter speed to four or six seconds (technique one).

- Set your shutter to "bulb" (technique two).

- If using the "bulb" setting, use a black piece of poster board to cover the lens in between bursts.

Light and Shadow

My wife, Ally, will spend hours just enjoying and looking for unique designs and shadows. She can be out at any time of day as the various lights all create different and unique shadow situations. She absolutely loves looking for details, shapes, and designs with shadows involved.

This is a great exercise in photography if you find that you are just out and about shooting and want to look for something different to photograph.

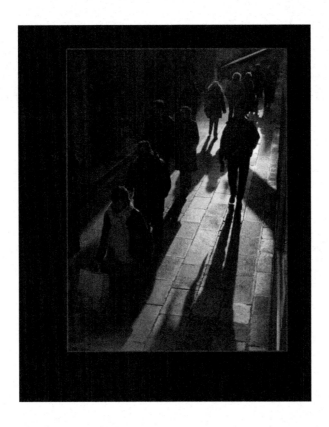

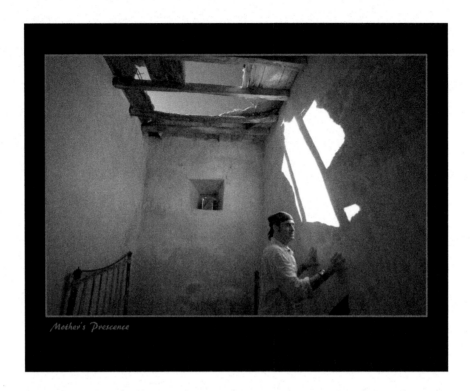

Mother's Prescence

This image taken by Ally is a beautiful reminder of the power of a photograph and light and shadow.

This was taken on the very small island of Sikinos, in Greece. Our dear friend Timothy owns property there that his grandmother and mother once owned and lived in. This little house is where his mother grew up, and in fact, the bedframe you see is the bed his mother was born in.

We were there together when Timothy went in, and Ally was able to capture this moving image of Timothy having a "moment." The light and shadow add to the power of this image.

Take Action Assignment: Light and Shadow

Preparation and Technique

- Take time to look for unique designs and opportunities created with shadows.

- Try different aperture settings to work with your depth of field, and notice how that affects your design and shadows.

- Photograph at different times of day to see the difference in the types of shadows that take place.

Painting with Flashlights

One of the coolest things you can do with long exposures is to have fun with flashlight photography! Remember, it's all about light. Any light! If you have a light source, you can take a photograph!

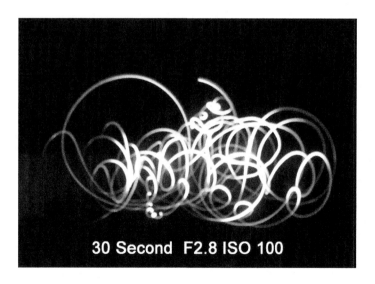

As you can see, light records no matter how dark the situation may be. The question becomes how long your exposure needs to be and the brightness of the light you are using. The idea of "painting with light" becomes clearer as an example when you use a light source, such as a flashlight, for your paintbrush!

In the image above, this entire vehicle was "painted with light" with a small, ten-dollar drugstore flashlight we keep in our camera bag. We have even used items, such as the flashlight apps on smartphones. Any light source can be used to paint with light.

The fun thing about painting with light this way is that it is very rare to get the exact same image twice. In the above image, I set up the camera on a tripod, and because I did not have a remote shutter trigger, I then placed the shutter on self-timer.

Upon hitting the shutter, there was a ten-second delay before the shutter actually opened. After hitting the shutter, I ran to the vehicle. As soon as the shutter opened, I started to paint the vehicle with light. The result is a flashlight-lit image of the vehicle. During the exposure, there was no alternate light available, and it was pitch black outside. This shows what you can do with just a small flashlight!

Here is a technique combining the long exposure of the freeway and the simple flashlight being used to expose Ally. Creativity is limitless, and this is a great self-photographic assignment to do. This is a fifteen-second exposure. You may notice that Ally is not entirely sharp. This has to do with her slight movement during the exposure.

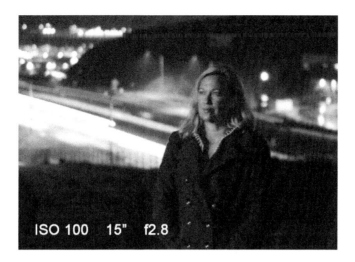

ISO 100 15" f2.8

Once again, painting with light can be used in fun and creative ways. Below, we had fun in the pitch black spelling our names. When you write your name, it will appear backwards, so you need to flip the image horizontally to read it correctly.

The image above shows the original thirty-second exposure before flipping it in software.

Here is it after flipping it in Photoshop.

Street Photography—Life Images

Street photography in itself is truly an art form. An entire book could be written on this subject, and in fact, it is a book I am planning on writing in the *Photography Demystified* series at some point.

In writing an entire book on the subject, it will allow me to spend a great deal of time not only exploring the subject with you, but truly delving into the intricacies of its many facets.

It may seem odd to you that an entire book could be written on street photography; however, there truly is a lot to this type of photography. In fact, some of the great photographers of our time, such as Henri Cartier-Bresson, are not only credited with helping to create this style of photography but are known for capturing moments that are decisive and emotional, leaving the viewers impacted by the story they have seen in an image.

Although my plans are to write an entire book on the subject, I have decided to include a chapter in this book now, as I feel it is an excellent subject for photographers to start to explore if they have yet to do so.

I myself have really just started to photograph more and more "life images" of the human condition. Inspired by books, such as *Humans of New York* by Brandon Stanton and Henri Cartier-Bresson's work, I see a place for this photography I really haven't done much of on my own, yet!

Although some may say that the photography itself is just average, when looking at some of these works, I would disagree. Whereas an urban image of a street scene may not contain all the perfect technical savvy, as found in the work of a landscape photographer spending hours to get the "one shot" in the perfect "light," these photographers are more concerned about the human condition and sharing stories to help change the way we see the world and those that live in it.

In Humans of New York, I would applaud the photographer and author for doing something that resonated with the human spirit. Each subject photographed along with his or her story is a poignant look into the real people that live in New York. What an amazing way to connect with the world around us!

Street Photography Means What Exactly?

Street photography does not mean you need a street in the image. It simply is a term used more and more frequently to describe photographing moments of scenes that are candid, emotional, and poignant.

More often than not, urban landscape and people are involved in the images. The goal of the street photographer should be to capture life as it happens—to document those moments that are witnessed and to press the shutter at the moment in time that creates feeling, mood, and depth in a situation.

This may mean the subject or subjects know you are photographing them. It may mean they do not. Whether they do or do not is only relative to that which you are trying to capture. The most important aspect should be the human spirit and the part of that term, the human condition, they seem to be living out. Sometimes this is happy, joyful, and full of life. Other times, it can be sad, dark, and in some cases, full of death and destruction.

Street photography is not for the weak of heart!

You must be willing to place yourself in situations where you may be noticed. You may be saddened, and you may even be in unsafe conditions if you are not careful.

Doesn't that sound like fun?

Honestly, I would say street photography is NOT fun. It IS, exhilarating, storytelling, and emotionally satisfying, and can be an incredible testament to people's lives. In my view, it can be a catalyst for social change. This is why I love street photography and am on a quest to pursue it more in my own career. From those experiences, I will be creating a new book as mentioned on the subject. In fact, just writing as I have so far is stirring in me to get out and photograph life scenes more and more.

For now, let's explore it a bit to help get you started.

Gear

Although street photographers do carry full DSLRs with lots of lenses, etc., it is more practical to be lightweight in your gear, which will allow you to move quickly and efficiently if you are actually photographing out on the urban streets. It will also allow you to be a lot less noticeable, which is a key to capturing real-life moments and people in many situations.

Many small, versatile, high-quality cameras are now available. The Fuji X100 S is an excellent example of this.

Some may consider it a downside to not have long telephoto lenses. However, zooming in on your subject does not truly allow you to become a part of the action. In order to truly create emotionally impacting images, I believe it is important to be in the thick of it all and actually "feel" what is taking place.

Yes, this puts you close to the action, which of course can carry with it a lot of its own predicaments, which I will discuss. But this is a necessity if you really want to create impacting street photography.

So how do we do this? How do we get into the action? How do we keep ourselves hidden when needed or involved with someone when not? How do we keep ourselves safe and how do we gauge what is appropriate to shoot in given situations?

Getting Into the Action

Getting into the action simply means you have to go out and find it! Spend an hour in any big city, and you should be able to easily find more subject matter (people that are interesting) than you

know what to do with. It doesn't take long to walk the streets of San Francisco, as an example, and come across plenty of characters and situations that can make amazing, interesting photographs.

As you are just getting started, just take it slowly. In fact, one of the best ways to start is to pay people to photograph them. Yep, I said pay for it! What do I mean by this exactly?

Again, any large city in the world will have plenty of subject matter, including street performers. Street performers are great subjects, and they love to be photographed, for a price! In my mind, there is no problem at all with that. Why not? I see it like this: you have a need, they have a need, and together, you both win.

Do not be cheap though! If you see a street performer, simply go up and ask them if they mind your taking their picture. Tell them you are happy to give them a few bucks. If you prefer, just photograph them a bit, but then do not leave without obliging them for their services. They are legally on the streets doing what they do and trying to make a living. I suggest at least a few dollars, and if you spend a lot of time, give them more.

In photographing street performers, you are getting your feet wet, so to speak, in the street photography scene. You are taking photographs of street scenes, yet there is no real pressure or concern about the situation.

However, what about situations that are truly candid? How should those be approached? The answer—very carefully.

Respect

The first rule in street photography where people are involved is respect. It is important that with any persons you choose to photograph, that you respect them. You never make someone feel inadequate or less human because of the condition that they may be in.

I have photographed in some of the poorest places in the world, and respect is the key to the human spirit. If we had more of it, we would find ourselves living a more peaceful life.

Do not let your photography be any different.

This does not mean that every time you photograph a person that they have to know you are capturing them. However, always be diligent in whom you are photographing and WHY you are photographing them. More often than not, as long as you respect people, you will be fine.

It is also VERY important to understand the cultural differences in locations around the world. Some cultures are totally happy for you to photograph them and enjoy it. Children can be a wonderful experience to photograph candidly. ALWAYS ask for permission though.

Other cultures may feel like you are taking advantage of them for your own financial gain (they think you sell their pictures), or they simply do not want to be photographed as a matter of pride,

for instance, if they are living in a tough situation, such as extreme poverty. It may be simply that their culture doesn't like being photographed from a spiritual side. Respect that!

A Smile Goes a Long Way!

If I am approaching a situation where I know that the person(s) I want to photograph will know that I am taking their picture, I simply follow a few personal guidelines. First, I smile at them. It is amazing what a smile can do! Next, I ask permission to take their picture. If they say no, I respect that and move on. If they ask for some money to do so, I pay it! YES, I pay it! Why not? I mean what is a few dollars or couple of coins in a foreign country going to set you back? Not much, and you are helping that person out.

Next, after I take a few images, I show them. This is awesome because now in the digital age we can immediately show someone their photograph. Many people have never seen their own photograph in many parts of the world. I show them and smile and share with them. Remember, it's all about the human spirit in these situations. Again, a smile goes a long way!

One of the awesome things about photographing people is that no matter the language or cultural barrier, in an instant, a photograph can be your language and create friendships!

Here I am (image above) with some of my friends in a village in Mozambique. Our language was one of smiles brought on by showing a digital photograph to them as I walked through their village.

Keep Yourself Hidden

Not every situation is going to be where you want to be seen taking photographs. Sometimes if you are seen, you lose that candid, special moment, even if the subject is okay with your photographing them.

This is where I go into "stealth mode." Stealth mode is when I work very quickly and stealthy, under the proverbial radar, so to speak.

Here is how I accomplish this. I start by shooting in shutter priority (Tv or S on the mode dial). I set my shutter to 1/1000th of a second during daytime shoots. I also set my ISO to "auto." In this way, I am controlling what I need to capture—action—but allowing the camera to adjust my ISO and aperture for me. This means that not every exposure will be perfect and dialed-in. That is just fine. You are not going for perfection here; you are going for moments captured, and the "feeling" of that moment must take priority over the "perfect" exposure.

With the camera doing most of the work for me, I am able to freely move and shoot, not worrying too much about exposure perfection. It allows me the ability to photograph from the hip as well.

Many times, I will be shooting a situation from my hip, literally. I will hold the camera at my side, use a wide-angle lens, knowing I can crop tighter later (this way I do not cut off the scene), and I shoot constantly. People never know I am photographing.

Here are a few examples of this.

In the scene below, we were leading a photography tour in Istanbul. This gentleman got irate with our group as people were photographing him (without his permission and were not buying anything). I came up behind the situation and noticed what had happened. As he walked by, cursing at our group, I started to shoot from my hip.

I love this image as it shows his angst, it is candid, and it captured a moment in time our group would not soon forget.

I told the group afterwards that they forgot my rule of paying and smiling! Fifteen photographers lined up and started "shooting" away without even asking. Of course, he was upset. I am convinced that if they would have gone and purchased his product, he would have been fine being photographed. Remember—RESPECT.

In the situation below, this homeless woman was strung out on drugs. Situations like this are tough, yet they show the human condition, so they are important to document. For me, I document images like this because I want to show the human condition—the good and the bad and all that it is that makes up human stories. In doing so, you never know what you may accomplish for thought and change.

Once again, I simply walked by, camera at my side, shooting away as I passed. Not once did I look through the viewfinder. I never made her feel disrespected. Yes, the truth is, someone may say that I am disrespecting her anyway by photographing her without her permission.

I understand that argument. I also understand the need for society to see those that seem to be forgotten, lost, or mentally ill. In photographing the human condition, we cannot and must not forget about all those hurting in this world, and just show the happy things.

I asked "John" if I could take this image. I told him I wanted to hear his story. He shared with me his struggles and desires to be a member of society again.

Take Action Assignment: Street and Life Images

Preparation and Technique

- Visit a location, such as a big city or area where you know that "life" will be happening.

- Select a wide-angle lens (as wide as you own anyway).

- Set your mode dial to "shutter priority" (Tv or S).

- Choose a shutter of at least 1/500th of a second. This will help you capture most scenes if you are walking by slowly. Go higher on the shutter if possible for the light you are in.

- Photograph in stealth mode, and see what you come up with!

- Be safe and have a friend with you, especially if you wander down any alleyways, etc.

Take Action Assignment: Street and Life Images #2. Put yourself out there!

Preparation and Technique

- In the same location, ask someone if you can take their photograph!

- Let them know you are working on a photography project and this is part of your "assignment." It will take you out of your comfort zone, but just smile and be bold! You can do it!

HDR—High Dynamic Range

In recent years, there has been a huge surge of photographers using a technique known as HDR, or high dynamic range. This process is done by bracketing your images, which simply means taking several photographs, at various exposure values, and then blending them together to get the entire tonal range of a scene that would otherwise not have been possible in one photograph.

I am going to share this technique with you, the benefits of what it can do for your photography, and some simple ways to accomplish it without a lot of Photoshop expertise.

However, this chapter comes with a BIG DISCLAIMER! Please DO NOT over-use the HDR method! So many people start using HDR, take their photographs, and make them look completely unnatural and unreal.

I know that art is subjective, and everyone can do what they wish, BUT please understand the goal of creating amazing photographs is just that—creating an amazing photograph, NOT an oversaturated, crazy color scheme image that looks unnatural.

Many photographers I know, including myself, will tell you that they have overdone their HDR methods in the past and now try to avoid creating images that just do not look natural. At first, it may seem really cool, but eventually, you will notice that you will find yourself more and more thinking you overdid the method.

Think of it like cooking with garlic. Just because most people like garlic, doesn't mean everyone wants their entire meal to be oversaturated with it. My rule on working with HDR is that as soon as you think it looks good, take the process back a bit. You will be glad you did! Just like adding garlic to your meal . . .

Why HDR?

In any given daylight scene, there are seventeen stops of light. That is a HUGE range. It is not possible for a camera sensor to contain all of that range in one single image. On top of that, if you are photographing an image that has a large range between the light and shadow areas, it is not possible to take one image and see the detail in both the highlights and the shadows. The sensors simply cannot get all of that information with such a huge range between dark and light.

We have learned that you can use a filter in some situations to help with this. By using the split ND filter, you can help to get the lighting that is bright equal in exposure to the other areas of the image that may be darker.

Another way to do this and also get a lot more range of the light that is in the scenes is to blend images together. The process of taking photographs of the same scene, exposing for each area of

that scene, and then merging them together to get the entire range of light and tones is known as HDR.

In fact, you may have noticed that your smart phone has this capability these days.

Here is how to do this. First, you must use a tripod as your images will be blended and you do not want to have them not line up correctly. I usually find that three to five images are all you really need to capture the range of any given scene.

Some photographers will blend fifteen images together, but the reality is that after a few, you can neither really see the difference, nor can a printer even print all the range.

Start by taking one image with the light meter lined up at the center. Next take an image that is overexposed on the highlights but that allows the shadow details to be seen. Third, take an image that is underexposed but allows the detail in the highlights to be captured.

When taking your photographs, there is a couple of ways to capture your images. It is important to note that you do NOT want to change the aperture setting from image to image! As the aperture is what controls depth of field, if you change that and then blend the images, they will not line up correctly.

In order to avoid this, use ONLY your shutter speed to change the exposure setting.

My technique is to choose the aperture I like and then simply, by following the light meter, adjust with my shutter speed to get the exposure values I prefer.

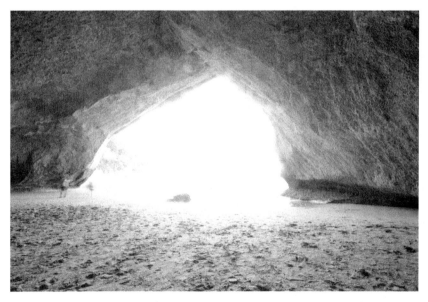

The above image is exposed for the shadow areas.

The next two images are exposed for the mid-tones and sky.

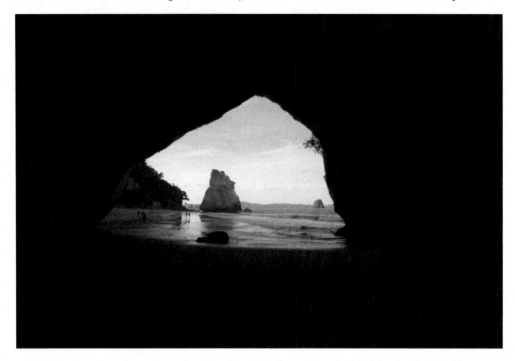

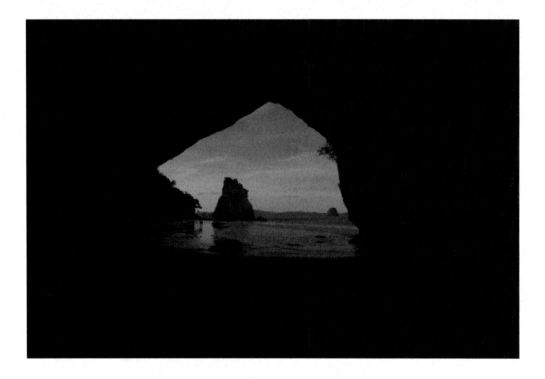

The final image is a blended combination of all three images placed together using HDR software techniques.

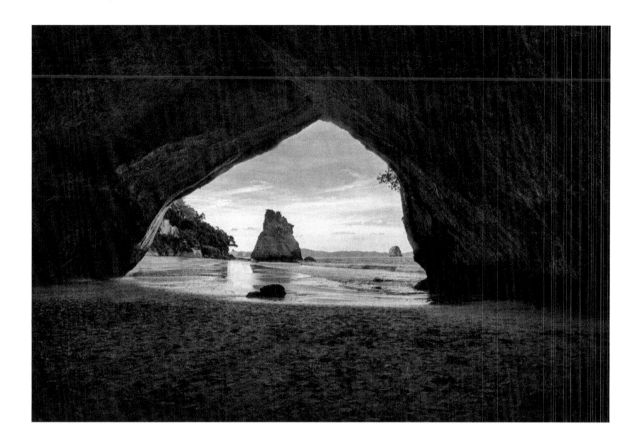

Auto-bracketing

Most new digital cameras have a feature known as auto-bracketing. This feature will allow you to set your camera to take three to seven shots with the push of the shutter once, yet it takes several images at various exposure values.

You can find this feature in your camera menu system, and it looks like this.

If the exposure value is not that extreme and you need to shoot quickly, this is a good way to go. The reason I choose to manually bracket, as above, is that I prefer to shoot exactly what I want for the exposure variances.

In auto-bracketing, the exposure values are set equally. For instance, you can set the bracketing to shoot one stop over- and one stop underexposed. Or four shots with two over- and two under-, but they are identical in stop differences.

Whereas if you manually choose, you can do exactly what you like in regards to your bracketing. I might choose to overexpose by three stops and underexpose by five, as an example. The idea is that I can control exactly how far on each side of the bracket I want to go, and for myself, I find it simpler just to adjust the shutter speed to get what I prefer.

Blending the Images Together

There is a variety of ways in post-production in software, such as Photoshop and Lightroom, to blend your images. Nik software and other programs are also available that make the blending method very simple nowadays.

Here is a link to my friends at Photonerds Unite: www.photonerdsunite.com

Check out their free tutorial on blending methods they use, and also subscribe to their YouTube channel as they are constantly coming up with new tutorials.

Take Action Assignment: Create an HDR Image.

Preparation and Technique

- Use a tripod.

- Set your exposure by setting your ISO and aperture setting first.

- Set your shutter speed by aligning the light meter in the center.

- Take two images overexposed (one at two stops over- and one at four).

- Take two images underexposed (one at two stops under- and one at four)

- Use the techniques in Photonerds Unite to blend your images.

Final Thoughts and Send-Off

Thank you for taking the time to read and enjoy my second book in the *Photography Demystified* series. As much as I love photography, I truly find that I love helping others in creating lifelong memories and photographs just as much.

It is my sincere wish that you not only learn from my books and techniques but that you come away inspired to go out and photograph and capture the world around you.

After all, photography is a wonderful gift we have to see and document our lives, travels, adventures, and much more.

I personally want to invite you to join Ally and me, as well as our awesome team, on one of our many photographic adventures around the world!

Please visit our website www.mckaylive.com where you can learn all about these amazing tours and the McKay motto of:

- Photography

- Travel

- Friendship

- Adventure!

Thank you again for reading!

—David

About the Author

David, along with his wife, Ally, owns and operates McKay Photography Academy and McKay Photography Inc.

The academy leads tours, classes, and workshops throughout the world. Their studio is known for high-end artistic portraiture.

David holds the degrees of Master of Photography, Craftsmen and Certified from Professional Photographer of America.

David lives in El Dorado Hills, CA just east of Sacramento and has been a professional photographer for over 29 years.

Visit the academy web site at www.mckaylive.com

Connect with the McKay's

- Facebook—https://www.facebook.com/mckayphotographyacademy

- Instagram—#mckaylive

Learn PERSONALLY with David and Ally and their awesome team on a photography tour!

Check out http://mckaylive.com/photography-tours

Recommended Resources

www.Photorec.tv

www.youtube.com/user/camerarecToby

An awesome web site and YouTube channel with our friend Toby.

TONS of content and TONS of gear reviews and help!

www.thinktankphoto.com/pages/workshop?rfsn=141206.b44047

Best camera bags we have ever used! LOVE them!

www.photonerdsunite.com

Fantastic site with TONS of helpful content.

This site is run by our own instructors Adam and Chris

ꙅSPIDER
CAMERA HOLSTER

www.spiderholster.com

Great way to handle your camera! One of my favorite new items I use!

WHAT GEAR
DO YOU NEED?

Let us ship it right to your door, business or hotel!

TAKE 10% OFF ANY RENTAL
OF $125 OR MORE

Use Code:
DEMYSTIFIED

All prices include roundtrip standard shipping. Only valid on rentals. Cannot be used to purchase used
gear listed for sale. Cannot be used with any other coupon. Expires December 30, 2016

www.lensprotogo.com

The source for all of your rental gear needs!

If you want to become a Best Selling author . . . like I have . . .

Watch the video course: https://xe172.isrefer.com/go/firstbook/dmckay22

If I can do it, YOU CAN DO IT!

—David McKay

PS—Hundreds of people are tackling their books using this three-step, FREE video course, "From 'No Idea' to Bestseller." Join them now.

Urgent Plea!

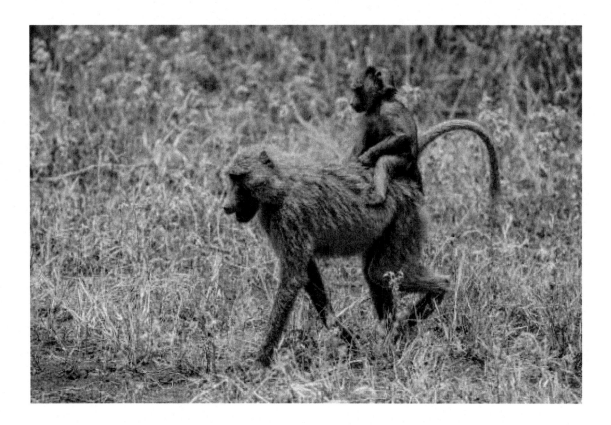

Thank you for reading my book! I really appreciate all of your feedback, and I love hearing what you have to say.

I need your input to make the next version better.

Please leave us a helpful REVIEW on Amazon on my book page!

Thanks so much!!
~David McKay

CPSIA information can be obtained
at www.ICGtesting.com
Printed in the USA
LVOW06s0003160817
545177LV00030B/1524/P

9 781945 177361